Focus
on
African
Art

FUSION: West African Artists at the Venice Biennale

FUSION: West African Artists at the Venice Biennale is published
in conjunction with an exhibition of the same title organized and
presented by The Museum for African Art, New York.

Text Editor: David Frankel
Design: Linda Florio Design
Publication coordinator: Carol Braide

Trade edition distributed by Prestel-Verlag, Mandlstrasse 26, D-80802
Munich 40, Federal Republic of Germany, Tel. (89)38-17-09-0; Telefax
(89)38-17-09-35. Distributed in continental Europe by Prestel-
Verlag,Verlegerdienst München GmbH & Co. KG, Gutenbergstrasse 1,
D-8031 Gilching, Federal Republic of Germany, Tel. (8105)2110;
Telefax (8105)5520. Distributed in the USA and Canada on behalf of
Prestel-Verlag by te Neues Publishing Company, 16 West 22nd Street,
New York, NY 10021, USA, Tel. (212)627-9090; Telefax (212)627-9511.
Distributed in Japan on behalf of Prestel-Verlag by YOHAN-Western
Publications Distribution Agency, 14-9 Okubo 3-chome, Shinjuku-ku,
J-Tokyo 169, Tel. (3)208-0181; Telefax (3)209-0288. Distributed in
the United Kingdom, Ireland, and all other countries on behalf of
Prestel-Verlag by Thames & Hudson Limited, 30-40 Bloomsbury Street,
London WC1B 3QP, England, Tel. (71)636-5488; Telefax (71)636-4799.

Library of Congress catalogue card no. 93-078927
Paperbound ISBN 3-7913-1327-4

Printed and bound in Japan.

Focus
on
African
Art

FUSION: West African Artists at the Venice Biennale

by
Thomas McEvilley

The Museum for African Art, New York
Prestel, Munich

Acknowledgements

The logistics of producing an exhibition in Europe of work in Africa required help from many people on three continents to whom we express our warmest thanks. First among them is Philip Rylands of the Peggy Guggenheim Museum, Venice; his able assistant Renata Rossani, and intern Philip Reeser who helped with the installation along with Tom Kotik, Kathy McAuliffe. The difficult task of packing and moving the works of art was ably accomplished by Erica Blumenfeld, our Registrar. This catalogue text is the fruit of the fertile mind of Thomas McEvilley whose words and interviews we are proud to publish. We thank Carol Braide for coordinating, and Linda Florio for designing the book, and David Frankel for editing the texts. At various points, Bara Diokhane, and Elisabeth des Portes gave us important assistance for which we are grateful.

Thomas McEvilley's interviews were translated by Susan Vogel (Dime and Dia), Jerry Vogel (Santoni), and John Cavaliero (Ouattara). Tapes were meticulously transcribed by Carol Braide.

All the photographs were taken by Jerry L. Thompson to whom we owe yet another debt of gratitude.

This exhibition was created at the invitation of the Rockefeller Foundation Arts and Humanities Division. We thank them for their confidence in us, and for generous funding. Additional support was kindly provided by Lincoln Kirstein.

But above all, we are grateful to the artists who have allowed us to exhibit their works and who shared their personal thoughts with us in the interviews.

Susan Vogel

Contents

West African Artists at the Venice Biennale

Susan Vogel

This exhibition of contemporary African art was originally organized for the 1993 Venice Biennale, where it marked the second occasion in the institution's history on which African countries had represented themselves. The show is intended to contribute to a new understanding of "African art" that will remove it from the realm of the ethnographic, and place it firmly within the framework of the transcultural aesthetic that has become accepted practice among Western artists. The free-ranging references found in contemporary African work may come as a surprise to those who remember it as bound by Africa's great art of the past, or who expect it to be subservient to contemporary Western art. In their melding of cultural codes from their own ancient traditions and from the cacophonous present, contemporary African artists may have independently arrived at their own post-Modern aesthetic.

Dakar and Abidjan, where most of the exhibiting artists live, are quintessentially post-Modern cities—heterogeneous, multicultural, filled with clashing contrasts and mobile populations. In these cities now, culture is reinvented every generation—or faster. Senegalese and Ivoirian artists are familiar with modern and contemporary Western art, but are not particularly preoccupied with it. It is simply one of the multitude of sources of inspiration that surround them.

At a geographic and spiritual remove from Western art movements, the artists presented here share certain assumptions about art that are distinctly their own. The status of the art object—generally easel painting and sculpture—is taken for granted, and the work is expected to refer to the external world in some way. Art concerned primarily with art or with issues of form is virtually never seen in Dakar and Abidjan. And, in keeping with cultural values, the work presents personal emotions with discretion and reserve. Political and sexual feelings are most likely to be veiled, and expressed indirectly, even though the artists exhibited here generally work independently of their official national art establishments. A brief overview of each artist's work demonstrates their wide differences—and their easy use of Western modes of expression for their own ends.

Arguably one of Africa's finest artists working in an international contemporary style, **Mor Faye** died in 1984, before African artists would be shown at the Venice Biennale. He would in any case have been an unlikely candidate, since, rejected by Senegal's official art-supporting organizations, he had refused to participate in exhibitions during the final decade of his life. He was an art teacher and a student of world art though he lived almost

his entire life in Senegal, struggling to survive. The mental institution in which he spent his last two years afforded him the materials and the freedom in which he created his most fully realized works. A superb colorist who relished the sensuous fluidity of paint, Mor Faye absorbed the vocabulary of a dozen modern European masters, and created work alternately idyllic, erotic, nightmarish, and whimsical, but always his own.

The wood and metal of **Moustapha Dimé**'s suggestive figures do not always reveal their origins, and the sculptures signify independently of our recognition of their sources. But they are made almost entirely from careful selections of discarded manmade things—not mass-produced junk, industrial garbage, or the waste of a gluttonous materialism, but the local detritus of Dakar. Worn wooden bowls, mortars and pestles deformed by use, ruined fishing boats—perishable things that have served their time are reshaped and find new life in his figures. All are ordinary, local, handmade, and related to the serious business of feeding people. They can be seen in use in every household and for sale in every market.

These objects bear witness to lives of hard work. Humble but not trivial, the objects Dimé selects for his sculptures are timeless, not fleeting in their presence. We know that when they wore out they were replaced by others just like them, part of a long succession of similar objects. Dimé's contemporary sculptures are related to history, and suggest that modern men and women are only a recycled version of their ancient but still vital traditions.

In an explosion of creativity, **Tamessir Dia** developed a new style and created a large number of paintings in the first months of 1993. These new works, painted directly with his hands, were partly driven by the intensity of his feelings about the human misery that he saw about him. The sufferings of women and children are most present in the series Tamessir calls "Cruel Song." The pale pastel colors, not favored in Abidjan, and not usually associated with misery, take on new meaning in the African context. The luminosity suggests the suffering of sick or homeless people unable to shelter themselves from the blazing equatorial sun.

Ouattara is a man of two worlds: he submerges, transforms, and appropriates motifs from traditional African cultures as readily as the materials, techniques, and styles of contemporary Western art. Ouattara prefers to guard a certain mystery about his references to traditional African and Oceanic art, references he does not want the critic to decode and identify. He wants the spectator to be free to dream and to see in his work whatever appears. Ouattara speaks of magic, spirits, and shamanism, and of his desire to infuse his paintings with a numinous presence. Texture, relief, and attached elements are the media of his paintings, which do not depict or evoke realities so much as constitute them. He creates presences, often architectural or monumental in feeling, that become new places for us to visit, spaces in which our minds are free to wander and to encounter spirits both ancient and modern.

For over a decade, **Gerard Santoni** has been inspired by traditional Baule cloth, which is composed of narrow bands sewn firmly together in parallel rows. But in Santoni's turbulent paintings the bands are unsewn, twisted and flying apart, blasted by a terrible wind. In traditional Baule life, the red stripe, called the "foot," is always at the bottom of the cloth.

Here, in a world turned upside down, it whirls through the middle of the paintings. It is easy to see here a metaphor for the forces of change stirring Ivory Coast, driven by mounting pressure to democratize an uneasy and unstable political system. Santoni's bands, huge, thickly clustered, and close to the picture plane, create a slightly suffocating atmosphere, evocative of the political hothouse of a small tropical country. But his work holds forth the possibility of escape. Light areas suggest deep space behind the bands, openings to an enlightened future.

African art (but not African artists) was at the inception of modern art, and has again become part of the critical nexus of art currents of the twentieth century. Even as Africa seems to be relegated to the margins of global politics and economics, its two-pronged relevance to the wider cultural world is, ironically, more central than ever. Beginning in the early years of the twentieth century, traditional African art provided a seminal inspiration for Modern Western art; as the century closes, contemporary African art has reemerged as another possible source of inspiration and new ideas.

African artists today propose new ways of incorporating the inherited lessons of twentieth-century Western art. Like European artists at the beginning of the century who, without subscribing to the beliefs it embodied, seized on African art for the formal ideas it contained, contemporary African artists fluently incorporate whatever they see as useful into their work, and they do this however they like. Regarding the Western art tradition from a distance, and without necessarily agreeing with its underlying assumptions, they are free to handle its vocabulary in new ways. In their art the Africanized (and other) forms of European Modernism return to us, digested, altered, fresh.

FUSION: Hot or Cold?

Thomas McEvilley

First Reversal

The first words Moustapha Dimé spoke to me in Venice this summer involved his immediate attraction, upon arriving at the airport, to the city's material foundations as substances he could reprocess in his work. Massive, weathered, waterbeaten pilings rise from the lagoon, marking the channel from the airport to the city. Their combination of power and decay—the future and the past—appealed to his sensibility.

For several years now, Dimé has made his sculptures from used materials—not used art materials, but everyday substances that had previously been involved in the societal life of Dakar, Senegal. In the importance he ascribes to the past history of these materials, Dimé's idea of art refers at least as much to reprocessing as to creation *ex nihilo*. On the one hand there is a sense of replenishment: the past is providing fuel for the future. On the other, a sense of transformation: art is transforming society, and being transformed by it. In terms of Western art ideas, Dimé's sense of involvement in community through the materials of his work could loosely be compared with Robert Smithson's idea of urban decay as the seedbed of art, or with Joseph Beuys's idea of social sculpture. "I use material," Dimé explains, "that leads people to be closer to their own lives."

There is also a site-specific significance to Dimé's designs on the underpinnings of Venice—a heart city of Europe, one might argue, one of the bottom-most foundation stones on which the continent's prestige and fame depend. This jewel box of a place, this incredible concentration of artworks, cultural artifacts, and urban icons, took hold of Dimé immediately. It might not be unreasonable to say that he wanted to remake Venice in his image, or in the image of his tradition—of Senegal and, ultimately, of Africa. Perhaps he was motivated in part by a desire to participate in Venice's artistic tradition. But his method went beyond this: in one of the many postcolonial reversals that would emerge in my conversations with four of the five West African artists who had been invited to the Venice Biennale, he wanted to remake Venice as Africa. (The fifth artist, painter Mor Faye, was included posthumously.)

Second Reversal

As Ivoirian painter Tamessir Dia and I walked along the corniche of the Giardini, the gardens that provide a permanent site for the Venice Biennale, after a three-hour interview session, he cast an eye over the sparkling surface of the water. "As the light gets long over

the lagoon and I gaze over the waters at Venice," he said, "I try to see it as Turner would have seen it. As I walk along here, I try to imagine what Leonardo would have felt like as he walked these streets, what he might have worn, what might have caught his eye. What a wonderful privilege to be in the same city where Leonardo lived!"

We walked along. The water brimmed and gleamed beside us. Venice hovered like an apparition against the horizon in the distance. Dia was surprised, he told me, at the apparent degeneration of Italian culture since the Renaissance: "I keep looking at present-day Italians and try to compare them with the Italians of the past and wonder how they did such great things in the past. When I look around, not only are the architectural monuments extraordinary, but the paintings as well. I don't see any link between the relics of the past and what I see today. I keep wondering, Are these the same people?"

This type of judgment, in which a contemporary culture is judged to have lost the glory of its past, plays a significant role in what Edward Said has called Orientalism: the dismissal, by westerners, of the contemporary peoples of the Third World by denigrating them in relation to their history.[1] For an African to exert such a judgment on the West is a profound reversal of the colonial relationship.

Digestion

"Digesting the West": so Susan Vogel, curator of the West African show at the Biennale, had expressed it on an earlier occasion.[2] Africa, which had been eaten before—carved into pieces and served up as a banquet entree at the Berlin Conference of 1984–1985—had reversed the relationship at last. This reversal seemed to crystallize in Dia's focused gaze, looking for Leonardo, or in Dimé looking at the pilings, the underpinnings of it all, the foundations of the West, and wanting not so much to assimilate himself to them as to assimilate them to himself, to honor them by reprocessing them into himself.

When Ouattara, an Ivoirian artist who has lived in New York for several years, told me he had attended a French school in Ivory Coast that had taught the history of the West, he added, without apparent resentment, "I was interested in the West." These Africans' interest in the West, how does it compare with the West's interest in Africa? Of course there are economic opportunities in the West, but these artists' gaze is not the same kind of gaze that brought the West to Africa for slaves, gold, and diamonds in the nineteenth century. Rather, a postcolonial gaze is involved, influenced by a sense of global interconnections. As Ouattara put it, "My vision is not based just on a country or a continent. It refers to the cosmos." And Ivoirian Gerard Santoni says, "I don't think it makes sense to have a specifically African painting. . . . I'm glad to see myself as part of a world tradition."

Four Phases of Identity

Modernism—here, let's describe it loosely as the ideology behind European colonialism and imperialism—involved a conviction that all cultures would ultimately be united, because they would all be Westernized. Their differences would be ironed out through assimilation to Europe. Post-Modernism has a different vision of the relation between sameness and difference: the hope that instead of difference being submerged in sameness,

sameness and difference can somehow contain and maintain one another—that some state which might be described as a global unity can be attained without destroying the individualities of the various cultures within it.

In terms of the issue of identity, the historical process has shown four stages. First, in the pre-Modern period, cultural identity was simply a given, unquestioned and unrelativized by the insistent intervention of other cultural realities. For most cultures, of course, this stage passed long ago, but it can still play a volatile and provocative role in contemporary thought as an Edenic myth of origin. Second, in the colonial or modernist period, the idea of cultural identity became a weapon or strategy used by the colonizers both to buttress their own power and to undermine the will and self-confidence of the colonized. Thus the cultural identity of the colonizer was claimed as naturally hegemonic, and that of the colonized as naturally slavish or imitative.[3] In art traditions, for example, the colonizer could dismiss the works of the colonized merely by labeling them products of an inferior cultural group.

This strategy led to two reactions among the colonized. One of them was a deliberate imitation of Western standards, an attempt to take on Western, supposedly universal identity. This was often characteristic of the earlier colonial period, before resistance had mounted. In the other, more delayed reaction, which constitutes the third stage in history's identity process, this effort was reversed: the colonized not only negated the identity of the colonizers, but also redirected their attention to the recovery of their own, perhaps abandoned, certainly altered identity. This is the phase of resistance, which leads to the end of colonialism. In Africa it is reflected in the *Négritude* movement, and in the pan-Africanist or Afrocentrist theory most fully articulated in the works of Cheik Anta Diop.[4] In a stunning reversal of the colonial relationship, Diop argues that Western civilization in fact was disseminated from Africa to the Greeks, who then covered up their borrowings. Influential in Africa a generation ago, his view is now favored almost exclusively by African-American thinkers. It is conspicuously not the attitude of the West African artists who came to Venice: "I am not limited to African culture," Dia asserts. "That would be absurd; it would be ridiculous for any African today to speak of Africanity or Négritude."

On the contrary, the attitude of the Venice artists seems to represent a fourth stage. Secure in their sense of identity, formed by whatever blends of African and European influences, they want to get beyond questions of identity and difference and to move into the future. (This fourth stage would seem to require the withdrawal of the colonial occupier, and thus has not yet dawned for, say, black South Africans. African-Americans too face a somewhat different process.) In the interview in this book, Dia illustrates this stage when he denies that anxiety about colonialism or neocolonialism is a significant thread in his consciousness. "I never felt conflicts in that way," he says. "I think people of my generation never had those conflicts." He notes that he and his peers were raised and often born after independence. They approach the future not with a determination to recohere around a long-lost identity, but with a feeling that that identity (along with the identity of the colonizer) is a thing of the past, and that the future holds new, more interesting identities for all.

Independence

Something like these latter two stages can be seen in the wake of colonialism around the world. In India, for example, artists now in their late forties and fifties were the first to express themselves as unencumbered by postcolonial anxieties.[5] In Africa this is more characteristic of artists 35 and younger, perhaps because independence came about fifteen years sooner in India. In both cases the artists in question were raised or even born under independence, and seem to regard the problems of their parents and grandparents as history.

In the late 1950s, Frantz Fanon, Jean-Paul Sartre, and others abominated colonized individuals who would assimilate to the colonizers' culture, or would split the difference and accept a hybrid cultural identity.[6] In India, such persons were once called Gunga Dins, after the notorious Kipling poem. At the time, perhaps, to condemn those who gave up the identity they had inherited was useful in the anticolonial struggle. But what about Gunga Din's son? Or his grandson? *His* inherited identity *is* a hybrid one, and in accepting hybridization he is not selling out his birthright but embracing it. To Indian artists I know, both the Indian and the British heritages are natural parts of themselves, much as two parents create a single offspring. Artists of fifty and under in India today tend to brush off the issue of colonialism-and-identity with some disdain, as a childish problem they have outgrown. To the Francophone West African artists in Venice, similarly, both the African and the French heritages are legitimate parts of themselves. For the most part they see the idea of restoring a precolonial identity as at best uninteresting, at worst preposterously impractical.

In art-historical terms, the four stages of identity might be described like this. First, the precolonial period, in which local visual conventions are passed on in a socially functional way. This is of course the era of so-called "traditional" African art. Second, the colonial period, in which the colonizers derogate the local artistic conventions. "The highly stylized African carvings," as one scholar put it, "were considered curiosities, at best, and evidence of the inability of Africans to represent things 'as they actually are' because they were culturally or racially inferior."[7] In place of inherited tradition, with its connection to ritual function, the Western colonizers held up to the colonized artist the vision of a nonfunctional, autonomous art. During this period, Third World artists who wished to enter the international art discourse had no choice but to turn their backs on their inherited traditions and adopt a School of Paris or, later, New York School style, which would offer no clue whatever to their own ethnicity or nationality. In India, this was the route of the Bombay Progressives in 1947 and after; in Africa, of artists such as Iba N'Diaye, who developed a lush and beautiful School of Paris–based style some fifteen years later.

In the third stage there is a nativist reaction, with the emphasis returning to some inherited tradition that is declared to have been the true one all along, if temporarily submerged by the illusory internationalism of the preceding stage. In India this stage was marked by the so-called Neotantric painting of the generation after the Bombay Progressives; in Africa one could point, say, to the so-called "Shona" sculpture that toured this country a couple of years ago, with its somewhat falsified nativism and artificial references to tradition. The fourth, postcolonial phase is one in which artists self-consciously accept

hybridization and make their work reflect the various forces that have formed them as individuals. Obvious examples include the Indian works of Gulam Sheikh, with their combination of Moghul and Siennese landscape styles; the Taiwanese ones of T. F. Chen, with their conflated quotes of Shinto and post-Impressionist styles; and so on.[8]

Hot or Cold?

Of course this four-staged model is not a law of nature. The conflict in Bosnia was mentioned by two of the four artists I spoke with as a horrifying spectacle: "I didn't realize," said Dia, "that civilized countries in Europe could do such terrible things." "Such terrible things" demonstrate that the third-stage emphasis on cultural identity can persist with a pathological singlemindedness, rather than being sublated into a wider arena.

But the question is: in the globalizing project that seems undeniably before us all, are we to be stuck with a slow, demanding attempt to force things together as in nuclear fusion (as in the former Yugoslavia), through a heat so great it might destroy them? Or can we—descendants of both colonizers and colonized—acknowledge the colonial karmic debt yet build from it into some more generous, less volatile geopolitical and geocultural fusion, as in the multiculturalists' vision of a global synthesis based on a good will that can arise after the postcolonial adjustment has taken place?

The Greek philosopher Empedocles's idea of the cycles of history seems troublingly relevant. On that ancient model, disparate things gradually merge, under the influence of the force of sameness, until everything is one and the world is united in an Age of Love; then, as the cycle progresses, things come apart again in a gradual ascendancy of the force of difference, until the world is fractured into an Age of Hate. If, at our present moment, the descendants of the previously colonized seek revenge on the descendants of the previous colonizers, the Age of Hate will be at hand in an extraordinary concentration, its outcome unforeseeable.

But the idea that a four-stage process is in play suggests otherwise. The vengeful attitude seems characteristic of the third stage—as in Fanon's *Wretched of the Earth*, published in 1961, in the watershed years of African independence. In at least some communities it is being succeeded by a fourth stage, better characterized by Wole Soyinka's recent novel *Isara*, in which African and European realities mix as permeable membranes to one another.

This balance of sameness and difference underlies much of the artists' interviews in this book. On the one hand Dimé's creative appropriation of Venice, for example, involved a synthesizing impulse, implying the idea of sameness or assimilation. On the other, it was also felt, I think, as a means to articulate himself, activating difference as well as sameness: he was looking, he explained, for elements "that would articulate my personality . . . [that would] show myself, my own personality, what made me different from others." His objectifying gaze at Venice, then, was premised on a view of life that assumed the primacy of sensibility and individuality—essentially a Modernist view. He assumed an assertive self or subject as the primary condition for the knowing of objects. Dimé stood and gazed at Venice as a Renaissance merchant king gazed at the globe that seemed to invite his domina-

tion and appropriation. This balancing of impulses toward sameness or conflation and difference or articulation was implicitly post-Modern: he was seeking a greater individuality through fusion.

History

There is a horrifying progression, a kind of Stations of the Cross, to the historical outline of the West's relationship with the rest of the world. In 1442, two years after Donatello's *David*, while Fra Angelico was working on his *Annunciation*, the first Portuguese slave ships raided sub-Saharan Africa. In 1455, as Renaissance perspective was being perfected as a means to objectify the visual realm for possible penetration into it, Pope Nicholas V granted Portugal exclusive rights to make laws and exact tribute in southern Africa, promising "to all of those who shall be engaged in the said war, complete forgiveness of all their sins."[9] In 1509, while Leonardo was working on the *Madonna and Saint Ann*, the first ship loaded with enslaved Africans moored in the Caribbean;[10] and on the sad recital goes, reaching a kind of culmination in 1884–85, one decade before the founding of the Venice Biennale, when the European nations, at the Berlin Conference, divided Africa up like a side of beef, with hungry guests getting shares. The reversal begins to be seen in the 1950s and especially the '60s, as most of the European colonizers pull out; it involves many strange and ambivalent moments, and seems now to be reaching a kind of milestone, in the early 1990s, with such events as the West African artists' appearance at the Venice Biennale.

Art History

In a narrower focus, this reversal is significant in terms of art history, which tends to follow political history with a brief lag. In the wake of the Berlin Conference, African artworks began making their way back to Europe. In fact, "the first examples of African art to gain public attention were the bronzes and ivories which were brought back to Europe after the sack of Benin by a British military expedition in 1897."[11] Soon European artists like Picasso found their visual sense challenged by the African objects that were increasingly coming into their ken, and they began to absorb some of the look of those objects into their own work, in parallel with the European nations' absorption of actual African territories and peoples. Ironically, then, a crucial element in the birth of modernism in the visual arts was a tradition that Europeans called primitive. Today, in the works of the African artists in Venice and others, that relationship is being reversed. Dia says that when he went to art school in France he was taking what belonged to him—not simply because Picasso and others had borrowed from Africa, but because his own identity is in part European, having been shaped in part by European forces. "What happens in Europe and America," he says, "belongs to me." Ouattara similarly says that when he saw Picasso's African-influenced work it was like looking into a mirror, but when he saw the paintings of Goya it was also like looking into a mirror.

The Biennale

In a narrower focus still, the postcolonial reversal occurring here has a special significance

in reference to the Biennale itself, as a single thread of art history. The Biennale is the type of cultural event that tends to arise when some form of capitalism is undergoing colonial expansion in pursuit of foreign markets. The cultural consequences of such an economic moment were felt in ancient Greece in the late archaic period, and again in modern Europe, when so much of the Greek experience was replayed in larger scale.

As part of the increasingly dominant free-enterprise competition in both these eras, various competitions developed, signs of the new ideology. It was at this stage in ancient Greece that artists began signing their work, which had previously been anonymous in execution and communal in meaning. It was also at this time that innovation began to be valued in art; until then, tradition had been primary. In the ancient games and competitions, which often mixed athletic and artistic events, the prizes were supposedly based on universals, and the states that competed for and won them were thereby validated as fit to pursue their domination of foreign peoples.

The Venice Biennale was founded in 1895, when the imperial centers of Europe were bonding in mutual complicity around the recent appropriations of Africa and southeast Asia. Italian troops were fighting for dominance in the Sudan that year; in fact Italy's imperial adventure in East Africa, with the dream of restoring something like the power of ancient Rome, set the background mood of the Biennale's first decades. And through most of the Biennale's first century, the institution played a role as cultural backup for colonial policy: only Western nations were invited to participate.

In ancient Greece it was the admission of a non-Greek state, the Macedonian, to a previously closed competition that marked the beginning of the end of this phase of social organization. Around 1990, similarly, the Biennale began showing abnormalities that coincided with changes in the society around it—with what has been called the shift from Modernism to post-Modernism. One sign was the sudden prominence of women: in the 1990 Biennale, Jenny Holzer represented the United States; in 1993, Louise Bourgeois represented the United States and Yayoi Kusama represented Japan. Equally historic was the invitation to two sub-Saharan African nations—Nigeria and Zimbabwe—to participate in 1990. And in 1993, Senegal, Ivory Coast, and South Africa participated.

Three Souls

At the same time that the Biennale has begun to rearrange its external network in response to changes in the outside world, its internal structure has begun to shift too. The director for 1993, Achille Bonito Oliva, decreed that this year's version would not merely survey recent artwork from the various participating nations, but would be dedicated to cultural nomadism—a dominant theme of recent post-Modernist discourse on shifting ideas of nationalism and identity.

The idealization of cultural hybridization goes back at least to the Roman poet Ennius's apparently proud remark that he had three souls because he spoke three languages. If, in the Modernist period, intense nationalism led to a belief in the single, crystalline cultural identities or essences of peoples or nations, the post-Modern, or postcolonial, readjustment favors the idea that human identity is composite, complex,

ambiguous, and hybrid. In a complex urban society (as compared to a neolithic village), identity is formed by a dizzying plurality of influences; any individual can be regarded as a cultural composite. But the post-Modern idea of hybridization goes beyond this, referring to the fact that the world's populations are now increasingly on the move, settling in each other's inherited territories, where they borrow parts of each others' identities (in clothing, food, philosophy, art, athletics) or survive as embattled fortresses within alien communities. The modern media also diffuse knowledge of different cultures widely. Dimé observes that people from his home town of Louga are now "everywhere in the world," and that he ran into some by chance in Venice. This global mobility, or cultural nomadism, is the underlying cause of cultural hybridization—or of its rejection.

Migrations

Similar processes of intermingling have happened many times before, in the vast migratory phases that have occurred on all continents—most self-consciously or programmatically in the Alexandrian Greek period. Now, however, they seem to be becoming global and irretrievable. Whether individual cultures will lose their separate integrities, or whether they will find some greater integrity from simultaneous local and global engagements, is the crucial question facing the world today. Dimé expressed the paradox when he remarked, "Even though I was born in Louga, I consider myself as a universal being." I asked him, "Do you ever feel tension between a universal sense of yourself and your desire to make sure that you understand your deep roots in your own culture?" "If I didn't succeed in keeping my own roots," he replied, "I could never be universal because it's on that basis that I can become universal, on the basis of my own roots. Because that's how I've become what I am. The humanity that I am in the process of living today is born in my own roots."

In the Modern period, the wave of cultural nomadism that seems now to be about to crest on a global scale began with the settling of the so-called New World, societies like Canada and the United States being almost completely hybrid, the results of nomadic forces. Subsequently, the wave of colonialism in the age of imperial capitalism brought Western people into other societies around the world, and with the end of colonialism the peoples of the Third World have begun spilling back in great numbers into Western societies. This worldwide tendency toward nomadism both binds the world in a global network of associations and sunders it by the tensions of nativist reactions.

Collage

In Western art, the tendency toward self-conscious cultural hybridization was first clearly encountered in the eras of *japonisme* and primitivism, both of which reflected the European intervention in the non-Western world. The assimilative or conflative tendency next asserted itself under the rubric of collage—beginning with Cubist collage (which, significantly, followed immediately upon the early era of primitivism) and continuing on through the present day. The discourse of collage was the forerunner to the post-Modern discourse of nomadism and hybridization. Developing intensely in the wake of the insistence on purity found in Abstract Expressionism and Color Field painting, the stress on collage,

impurity, and mongrelism was both liberating and prophetic, and foreshadowed impending developments in global culture.[12] In 1971, when the post-Modernist discourse was already self-consciously underway, literary critic Ihab Hassan wrote that "post-Modernism . . . dramatizes its lack of faith in art even as it produces new works of art intended to hasten both cultural and artistic dissolution."[13] The art in which Hassan found this "lack of faith" was the art of purity and wholeness—what one might call, following Derrida's "philosophy of presence," an "art of presence." In place of it arose an art that was essentially critical, promoting not unity but disjunction, not integrity but mongrelism. A few years later, Hassan would characterize the post-Modern as disjunctive, polymorphous, androgynous, and characterized by deconstruction.

Among the more influential formulations to follow was Charles Jencks's 1981 characterization of the post-Modern as double-coded, in contrast with high Modernism, which was single-coded and based on the positing of absolute truth and absolute identity.[14] But post-Modernism's relativization of truth and identity, its arrival at a sense of slippage or displacement, really leads beyond mere double coding into multiple coding. In 1982, Julia Kristeva wrote of "the abject," meaning "what disturbs identity, system, order. What does not respect borders, positions, rules. The in-between, the ambiguous, the composite."[15] The emphasis on collage was revived in Fredric Jameson's 1984 assertion that post-Modernist culture is characterized by pastiche,[16] "speech through all the masks and voices stored up in the imaginary museum of a now global culture."[17] Gilles Deleuze and Félix Guattari in a sense completed the thought process the following year:[18] they suggest that the underlying condition for a culture of pastiche is nomadism, the movement in which individuals are uprooted from their inherited matrices, and cultures are overlaid upon one another, combined and recombined in unpredictable ways. This process amounts, in their formulation, to "an absolute that is one with becoming itself, with process. It is the absolute of passage."[19]

Thus post-Modernism is fascinated by borders and interfaces between conflicting realities and senses of reality. It does not hold, as Modernism did, that one side of the border is right and the other side wrong; both are understood as right in different ways, and something even more right is felt in attempting to embody both truths, or many truths, at one time and in one self.

The category "cultural nomad" applies most clearly to persons who were born and raised in one culture and subsequently migrated into another; to persons who characteristically travel, and have a sense of the relativity of cultures; to people crossing boundaries in a variety of ways, including creative and professional. The situation of African artists at the Venice Biennale automatically involves a degree of nomadism, in that artworks produced in and by one culture are being exhibited and viewed in and by another. The presence of these African artists in Venice itself—an overwhelmingly white demographic area—is at the heart of the post-Modern moment.

The Four Stages Again

In the Modernist era, with its emphasis on sameness and identity, the confrontation

between cultures was experienced as simply a choice between this and that; usually the culture of one's birth would seem the right choice. The colonial situation both reinforced and confused this assumption. Certainly, as Memmi wrote, "even the poorest colonizer thought himself to be—and actually was—superior to the colonized."[20] Memmi's strange parenthesis, "and actually was," suggests the reversal of self-esteem in the colonized mind (in the second stage). But that reversal is reversed again in the reaction against colonialism (the third stage), when "the negative myth thrust on him by the colonizer is succeeded by a positive myth about himself suggested by the colonized."[21] The pursuit of this positive myth leads the previously colonized to "forego the use of the colonizer's language, even if all the locks of the country turn with that key . . . He will prefer a long period of educational mistakes to the continuance of the colonizer's school organization. . . . He will no longer owe anything to the colonizer and will have definitely broken with him," and so on.[22]

This is the attitude of the third stage of cultural identity, among the four discussed above. Memmi's powerful expression of it was written in 1959, at the height of the moment of decolonization; but with the generation raised after the colonial period, the third-stage rage about the colonial past seems to have given way to an alert curiosity about the future. Three of the four artists interviewed here express no ambivalence about using the French language or being shaped by the French educational system, and the fourth acknowledges his resentment of these traits but refers to it as a thing of the past. Dia speaks of positive aspects of the interaction between Europe and Africa today even as he reverses the orientalizing gaze. And Dimé wants to incorporate Venice into his art. The mentality of the colonized, so brilliantly expounded by Memmi, is apparently not theirs.

"Multiculturalism"

As the fourth stage dawns—when the post-Modern succeeds the Modern—the contradictory summonses of two or more different cultures are reconciled by the assumption that neither is true: that no particular cultural stance has ultimate validity. At this moment the multicultural situation can seem to highlight the absurdities of each culture, lending a certain nihilistic air to the space of judgment. Loss and liberation can seem about equal. In other cases, though—and this is perhaps the more completely post-Modern position—the resolution points a more positive way: toward a feeling that each cultural form is inwardly meaningful, and that the project of bringing them together without loss is worth one's while. Anthony Appiah has called such a stance the "capacity to make use of . . . many identities without . . . any significant conflict."[23] Referring to a conversation with Dimé, Dia said, "We talked to each other in Wolof; when I go to see my relatives I speak in my own language, Bambara; when I am with a Frenchman I speak French." The use of French, he says, is "not tied to any conflict."

In this project of getting beyond simple nationalism into a new stage of multiple human identity, the arts play a leading role, feeling out avenues of conflation and comparison. This does not mean the adoption of some neutral international style that bleaches out cultural particularities, as it did in the Modernist period. The post-Modern invitation is not to abandon one's identity in order to become Western but to balance one's identity with the

various global demands of the moment, including the demand presented by the temporary hegemony of Western technology and pop culture. Today, artists born in India, Korea, Japan, China, Turkey, and diverse Latin American nations are consciously creating styles that simultaneously honor particular cultural identities and make gestures of mutual incorporation with the Western tradition.

This accommodation with the West is desirable not because of some hegemonic assumption that only the Western art discourse defines the reality of art, and hence non-Western artists *should* desire to be included in it. There are artists in India who are working in traditional Indian modes, and artists in China who are working in traditional Chinese modes, with full satisfaction; this is part of the pluralized post-Modern situation. But another part of that situation is precisely that many non-Western artists *are* knocking on the doors of the Western art system, seeking the advantages it offers: the increased possibility of making a living through art; access to a large, focused audience; and entrance into a lively, even agitated discourse that promises to leave its record in art-history books and museums. The sense of artistic community in the West is intensely attractive to many non-Western artists, who often work in considerable isolation in their native lands. When I asked Santoni how he thought his work would be recorded in art history, he laughed and said, "I don't even think about that. I don't even think I am part of art history." And when I asked Dia, "What is your artistic community?" he replied, "I have never confronted this question." "In Ivory Coast," he explained, "there isn't much of a community of artists. Artists don't sit down together and talk about techniques or issues or anything. They live very separately."

For these artists, freed of the colonial conflicts that confined their parents' generation, it is easy to feel a common cause with Western artists. Dimé praised Louise Bourgeois's work, which he saw in Venice, as "full of humanity. I really felt the presence of a human being. It was not just something for commerce, but a kind of gift." Ouattara praised Joseph Beuys for his interest in "liberation through art," and he pursues in his own work the Beuysian goal of "a synthesis of spirituality and technology—to give technology a more humane quality." When I asked Dia if he thought that artists around the world were engaged in a kind of collaboration with one another, he replied, "That would be wonderful."

Recently the doors to the global art community, once closed and locked, have been opening in an increasing number of urban venues. The spread of Third World biennials, ultimately based on the Venice Biennale but not necessarily subservient to it, is creating new centers from which entrance into the global arena can be navigated. In Africa such exhibitions now occur in Cairo, Libreville, Kinshasa, Abidjan, and Dakar. Pluralism, which Appiah describes as "a fact waiting for some institutions,"[24] is now amassing institutions of its own. Reconceived art museums and refocused international exhibitions are not the least important of them.

The value of participation in this emerging multibranched art discourse is that contemporary art carried out in an atmosphere of global dialogue can accomplish things that a puristically maintained native tradition cannot. Exported from within a culture to the out-

side world, contemporary art is a type of visual diplomacy that introduces the peoples of the world to one another in their living reality. That such an introduction cannot be perfectly lucid is not necessarily a problem. When an object produced by one culture is received in another, there is bound to be a cognitive slippage, an unintended misperception on the part of the receivers. But it is precisely this "off" quality that offers a window of rich openness, through which new options may arise on both sides.

African Post-Modernists?

So, from the point of view of the West, the appearance of these five West African artists in the 1993 Venice Biennale can be seen as a distinctively post-Modern event, a signpost indicating the continued unfolding of the post-Modern idea of globality. But this is not to say that these five artists are post-Modernists. Seen from the point of view of Africa, or of the so-called Third World in general, their significance might seem quite different. Indeed, much of the Third World is concerned with entering Modernism, not with what it sees as the odd concept of post-Modernism. In much of the world, post-Modernism is regarded as strictly a Western idea; in much of Europe it is regarded as strictly an American one. And it is no doubt true that the United States, with its specifically hybrid roots, is among the most dedicatedly post-Modernist cultures. But this doesn't mean that post-Modernism is only about the West, or only relevant to the West. Though post-Modernism marks a shift in specifically Western attitudes, those attitudes concern the West's relationship to the rest of the world. Considering the wealth and power involved in such a shift, it is of deep relevance everywhere. Whether these African artists see themselves as post-Modernists or not, the fact remains that it is the complex of changes called post-Modernism that brought them to Venice.

Universals

In fact, the position these artists occupy on the continuum from pre-Modernism to Modernism to post-Modernism is understandably mixed and fragmented—like virtually everyone else's. Insofar as they have got beyond the various issues of colonialism, neocolonialism, and postcolonialism, they may be regarded as post-Modern. Yet their ambitions as artists, and their beliefs about what the significance of artmaking might be, also involve pre-Modern and Modernist attitudes.

All four of these African artists seem to invoke universals as in one way or another the basis of their work. Dia, for example, perceives in art a universal element that seems to arise from a personal sense of transcultural identification with artists from radically different backgrounds, cultures, and eras, as in his exquisite curiosity about Leonardo's feelings walking the streets of Venice on his brief sojourn there. Dimé's sense of the universality of art is based on Islamic religious feeling, the conviction that God has created beauty in the world and that artworks participate in this creation. For Ouattara, the transcultural nature of art is guaranteed by the conviction that magical symbols and intentions work across lines of cultural difference—as in the similarity he has found between his initiation symbols and cabalistic imagery. And for Santoni, the universal is rooted in a lonely, intransigent

individuality that sees a path-oriented isolation as fundamental to any moment of life, regardless of cultural conditions.

The Autonomous Artist

A second major sign dividing the pre-Modern, the Modern, and the post-Modern is the definition of the artist's role in society. In pre-Modern societies the artist was socially contextualized as an artisan; the Egyptian sculptor was on the same socioeconomic level as the Egyptian cobbler. With Modernism, a cultural epiphenomenon of early or market capitalism, the fine artist gets separated from the cobbler, becoming a sensibility in competition with other sensibilities for the discovery of innovative options. Underlying this separation is a belief in the artist's connection with aesthetic and spiritual universals. The pre-Modern artist, often working in religious contexts, may also have been connected with universals, but more communally—without the imperative of individual discovery.

The difference devolves upon the question of autonomy. The idea of the artist's autonomy, essential to Modernism, is in part based on the idea that the artist transcends social mores, being in touch with a reality that is prior to them, that is in fact their true archetypal meaning or source. Recent Western discourse has made much of the unnaturalness of this idea, pointing out that in traditional or pre-Modern (or merely non-Modern) societies, the profession of artist usually isn't separated from social matrices—from craft, from religion, from communal bonding. In fact it has often been suggested that the separate and so-called autonomous role "artist" may be an unhealthy sign of the alienation and reification of late capitalism.

My conversations in Venice do not support such thoughts, for these non-Western artists have all embraced the Western idea of the artist as following an autonomous path of self-realization and self-expression—though one supported by communal sympathy and cultural collaboration. They all feel pretty alienated from society; but at the same time, a bond of concern with it pervades their art. In the traditional or pre-Modern social setup, the artist was deeply embedded within culture, like the shoemaker. The situation of the African artists in Venice is more typically Modernist: they are separated from the body of culture, even alienated from it, yet they feel themselves as its heart and soul, its essence yearning for its body, and so on. In this they recall the essentially Orphic spirituality that pervades Modernism.[25]

Dimé, in the remarkable story that he tells in my interview with him in this book, seems to say that his life and sanity were salvaged after long travail by his full realization of the role of autonomous artist. Furthermore, this realization came to him in stages not entirely unlike those that traditional mystical texts ascribe to the discovery of spirit—the ascent of Mount Carmel, say, or the penetration into the Interior Castle. As he looks back over his life now, "I feel," he says, "I could never have been anything but a sculptor." Speaking of himself and other young Senegalese artists, he describes the path of art as a path of self-realization: "Each wanted to create his own originality, his own style." And Santoni remarks, "What I do is entirely personal. . . I use painting to express myself." He sees the artist's autonomy as constituted by the irreducibility of individual sensibility, and

the unquestionableness of one's solitary life-path. Action is regarded as inevitable, conditioned by the reality of one's sensing of one's path, and sufficient in its visual embodiment of that sensing. "I am following my way, my path," he says, "and I don't know where this path is going to take me."

For Dia, the role of artist involves both autonomy and communality. His work penetrates realms of feeling associated with the social suffering around him; his individual selfhood catches the vibration of the communal and reflects it back, like radar signals in a visual semaphore. Thus he feels that his work, though brought into being in almost hermetic isolation, is a direct response to his community. Dimé too, while pursuing his individuality through his work, directs it at the communal distress of "social outcasts" in Senegal. Ouattara holds to a more traditional sense of art as a magic of "the elders." Yet his homage to tradition is offset by deliberate multicultural mixing, and by a sense of art as future-oriented, even as a driving force in human progress, specifically in the reconciliation of technology with nature or spirit.

The pre-Modern artist, contextualized as an artisan, was discouraged from pursuing a path of formal development. For the Modernist artist, on the other hand, development of vision, and of that vision's formal realization, is of the essence. Those of Dimé's boyhood friends who went into traditional woodworking may be making the same types of objects twenty years later, whereas his work has gone through several stages in a twenty-year quest. The intensity and peculiar satisfaction of such a quest suggest that it is a process of making oneself into something fuller, greater, or clearer—a kind of self-articulation. Thus the four or five stages of Dimé's sculptural practice may be seen as four or five stages of his personal quest for wholeness. All four of these artists see their work as path-oriented, as a thread they follow through their investigations of form and material, a thread leading not merely to some formal and material end, but to a combined sense of autonomy and responsibility to group.

The Future

Self-consciously post-Modernist art sometimes tries to function as a benign promoter of the balance of sameness and difference, as a facilitator of a certain kind of future. Sometimes it interprets the mandate of the pastiche, or the double coding, as a combination of iconic signs from different cultures, a combination that would once have been called inappropriate. Chen and Sheikh are two artists who make this kind of conflation; the hilarious postironic Russian-American pastiches of expatriate Russian Alexander Kosalopov, and the media-conscious global conflations of the Zairean artist Trigo Piula, are two more. The works of all these artists can be interpreted, in one aspect, as highly self-conscious instruments of both analysis and prophetic vision. While they analyze selfhood into various factors, they also prophesy a future in which these factors collaborate harmoniously.

The works of the five West African artists in the 1993 Venice Biennale are less self-consciously theoretical than the post-Modernist pastiches of Chen, Kosalopov, Sheikh, and others who are consciously working on a synthesis of Western and non-Western modalities. But they exhibit a comparable sense of permission in regard to the cultural attributes of

cultures other than their own as well as their own—a permission that in the Modernist period was available only to the cultural agents of colonial powers.

Picasso's famous remark, haughty in its offhand imperialism, "All I need to know about Africa is in those objects"—meaning, evidently, in the *look* of the objects—now represents the attitude these African artists turn back upon the Western tradition. They are adopting elements of the *look* of Western artworks—elements of style, iconography, and materials—from aesthetic appetite alone, not much caring about the conceptual issues or culture-specific contents that we think saturate them. When they do appreciate specific borrowed elements conceptually, these include the Western idea of the autonomous role of the artist, and along with it the belief in art as a liberating spiritual force in relation to society and its problems. Untroubled by hybridization, armed with elements from both Africa and Europe, they are ready to move into the future.

1. Edward Said, *Orientalism* (New York: Random House, Vintage Books, 1979).

2. Susan Vogel, *Africa Explores*, (New York: Center for African Art, and Munich: Prestel 1991), p. 14.

3. This oneupmanship transpired in ways analyzed by Albert Memmi in his book *The Colonizer and the Colonized*, 1959 (expanded ed. Boston: Beacon Press, 1991).

4. See Ellen Conroy Kennedy, ed., *The Negritude Poets* (New York: Thunder's Mouth Press, 1975), and Cheik Anta Diop, *The African Origin of Civilization: Myth or Reality*, trans. Mercer Cook (Chicago: Lawrence Hill Books, 1974), and *Civilization or Barbarism: An Authentic Anthropology*, trans. Yaa-Lengi Meema Ngemi (Chicago: Lawrence Hill Books, 1991).

5. For more on these Indian developments, see Thomas McEvilley, "The Common Air: Contemporary Art in India," *Artforum* 24(10) (Summer 1986). Reprinted in an abridged version in McEvilley, *Art and Otherness: Crisis of Cultural Identity*, Kingston, N.Y.: McPherson and Company, 1992.

6. See Frantz Fanon, *The Wretched of the Earth*, with preface by Jean-Paul Sartre, 1961 (reprinted. New York: Penguin Books, 1983).

7. William Bascom, *African Art in Cultural Perspective* (New York: W. W. Norton and Company, Inc., 1973), p. 4.

8. For discussion of Gulam Sheikh's work, see McEvilley, "The Common Air"; for T. F. Chen, see McEvilley, "The Post-Modern Art of T.F. Chen: Images of a Global Humanity," in *T.F. Chen's Post-Modern Art: Neo-Iconography* (Tainan, Taiwan: Tainan County Cultural Center, 1991).

9. B. Davidson, *The African Slave Trade* (Boston: Little Brown, 1961), p. 10.

10. Arturo Morales Carrion, *Puerto Rico and the Non-Hispanic Caribbean* (San Juan: University of Puerto Rico, 1952), p. 5.

11. Bascom, p. 4.

12. In 1961, when the process of decolonization was progressing headlong, Thomas Hess wrote about what he called "impure art" in an essay entitled "Collage as an Historical Method," in *Art News* 60 (November 1961):70. The following year, Harriet Janis and Rudi Blesh traced the gradual ascent of collage practice through the late-Modernist period in *Collage: Personalities, Concepts, Techniques* (Philadelphia and New York: Chilton, 1962). The year after that, Allan Kaprow, one of the practitioners of impure art, wrote about collage as "impurity [meaning] a secondhand state, a mongrel," in "Impurity," *Art News* 61 (January 1963):31.

13. Ihab Hassan, "POSTmodernISM: A Paracritical Bibliography," *New Literary History* 3(1) (Autumn 1971): 5–30.

14. Charles Jencks, "Post-Modern Classicism—The New Synthesis," *Architectural Design* 5/6 (1980), and *The Language of Post-Modern Architecture* (London: Academy, 1991).

15. Julia Kristeva, *Powers of Horror: An Essay on Abjection*, trans. Leon S. Roudiez (New York: Columbia University Press, 1982), p. 4.

16. Fredric Jameson, "Post-Modernism, Or, The Cultural Logic of Late Capitalism," *New Left Review* 146 (1984):59–92.

17. Jameson, *Postmodernism, Or, The Cultural Logic of Late Capitalism* (Durham, North Carolina: Duke University Press, 1991), p. 18.

18. Gilles Deleuze and Félix Guattari, "Nomad Art," *Art and Text* 19 (October–December 1985):16–24.

19. Deleuze and Guattari, *A Thousand Plateaus*, trans. Brian Massumi (Minneapolis: University of Minnesota Press, 1987), p. 494.

20. Memmi, p. xi.

21. Ibid., p. 139.

22. Ibid., p. 138.

23. Kwame Anthony Appiah, *In My Father's House: Africa in the Philosophy of Culture* (New York and Oxford: Oxford University Press, 1992), p. ix.

24. Ibid., p. 144.

25. From Orpheus, by way of Pythagoras, to Plato—to whom, as Alfred North Whitehead said, all Western philosophy is a series of footnotes.

Mor Faye

In his short life Mor Faye achieved considerable recognition as a major Senegalese artist, and his work was exhibited as far afield as Rome, Liege and Paris. He was born March 26, 1946, and died of malaria November 6, 1984. Mor Faye's mother, sister and friends describe him as a hard worker and a caring son and brother. Over the years he experienced nurmerous breakdowns which required him to be institutionalized, a fact that has led to comparisons with Vincent Van Gogh.

Before he was seventeen Mor Faye had won three prizes in the Ecole des Arts du Senegal, Maison des Arts, where he studied under Iba N'Diaye. After earning a Master's degree in art education he taught in several colleges. He was reluctant be grouped with his contemportary artists, convinced that his work was superior, yet he did not promote himself. He participated in a number of group exhibitions, but after 1976 he no longer exhibited his work. At his death he left 800 paintings, and through the efforts of a Dakar lawyer, Bara Diokane and Spike Lee 400 paintings that had never been seen by the public were rescued from obscurity. After an eclipse of fifteen years Mor Faye's work was again brought before the public in Paris January 1991, in a retrospective exposition in Gallerie 39.

Opposite: *Untitled 165*, 1984
Gouache and India ink
on paper
65 x 50 cm.
Estate of Mor Faye

Untitled 334, 1981
Gouache and India ink
on paper
50 x 65 cm.
Collection of Diokhane
and Lee

Untitled 1000, 1983
Gouache and India ink
on paper
50 x 65 cm.
Collection of Mayam
Diokhane

Opposite: **Untitled 159**, 1984
Gouache and India ink
on paper
65 x 50 cm.
Collection of Diokhane
and Lee

Right: **Untitled 324**, 1983
Gouache and India ink on
paper
50 x 65 cm.
Collection of Diokhane
and Lee

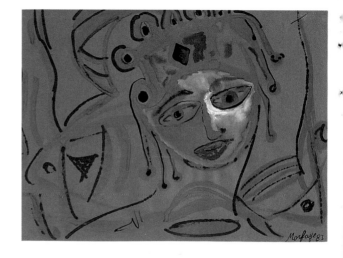

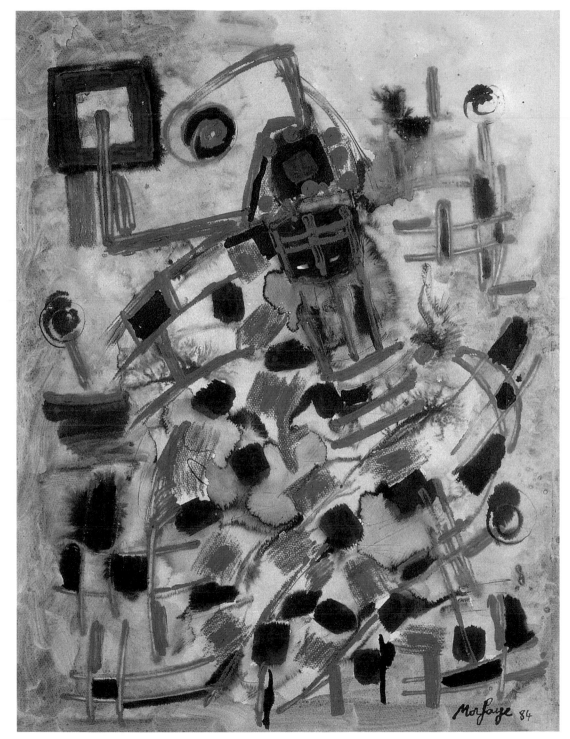

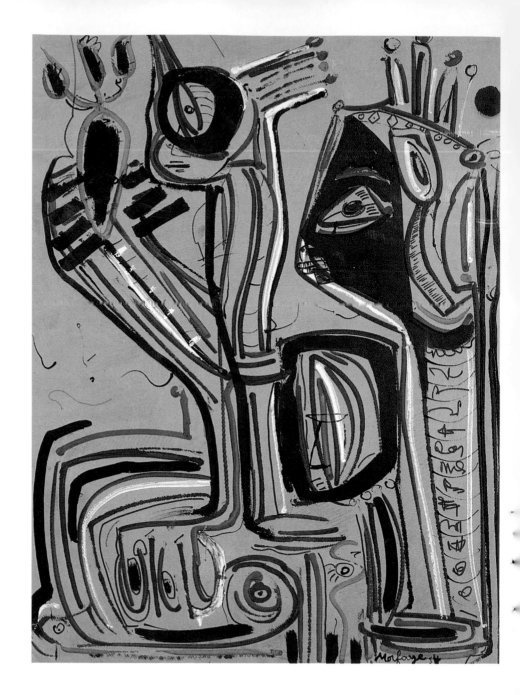

Right: *Untitled 175*, 1982
Gouache and India ink
on paper
65 x 50 cm.
Collection of Diokhane
and Lee

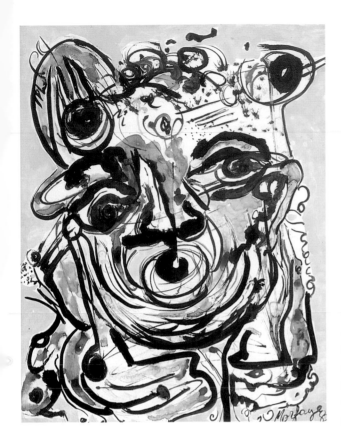

Untitled 172, 1983
Gouache and India ink
on paper
65 x 50 cm.
Collection of Diokhane
and Lee

Untitled 297, 1983
Gouache and India ink
on paper
50 x 65 cm.
Collection of Diokhane
and Lee

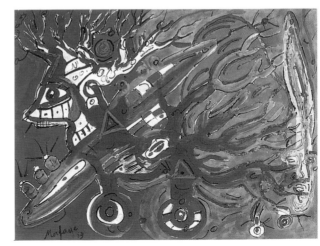

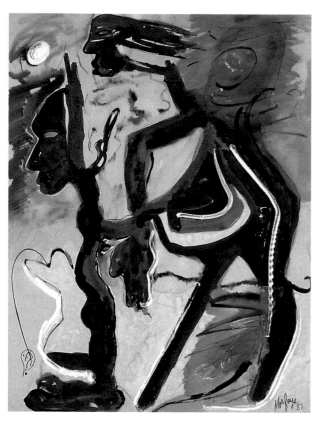

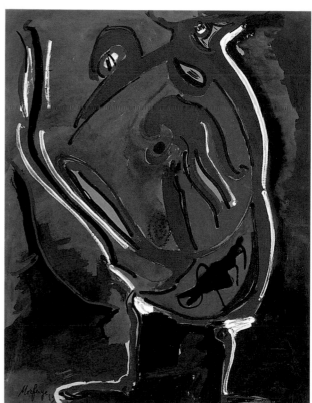

Untitled 85, 1983
Gouache and India ink
on paper
65 x 50 cm.
Estate of Mor Faye

Untitled 139, 1983
Gouache and India ink
on paper
65 x 50 cm.
Collection of Diokhane
and Lee

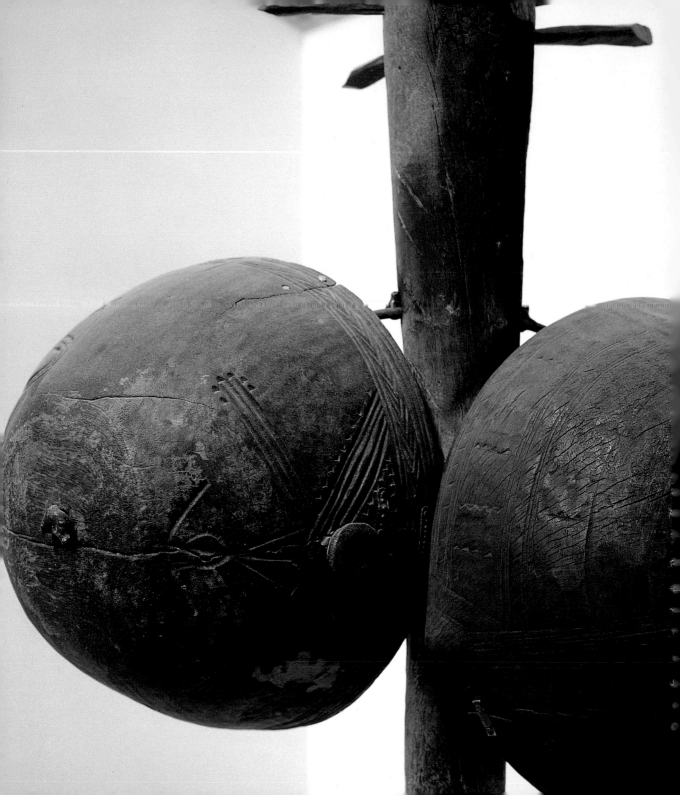

An Interview with Moustapha Dimé

Thomas McEvilley
Venice, 11 June 1993

Opposite, detail: *Femme sérère*
(Serer woman), 1992
Bowls, mortars, and pestle
145 x 49 cm.
Collection of the artist

Moustapha Dimé: When I came here to Venice, the first things that impressed me were the wooden pilings in the sea, in the lagoon, even right at the airport. If I could get them out, I would make a big sculpture out of them. It seems that when I walk around, the first things that hit me are the materials in the environment, the forms that nature suggests.

Thomas McEvilley: Nature—including the urban environment?

MD: Yes, even urban. Because the integration of the urban and nature is something! When they're well married, you find forms that aren't accidental. I'm confronting this issue in my work.

TM: This issue of the integration of culture and nature?

MD: Yes. Because in my city, when I was young, there was a lot of nature. But nature has begun to disappear. The desert is taking over in this region. I was born in Louga, one of the most agricultural regions after independence.

TM: Is it a Moslem region?

MD: Yes, Moslem. But you know, the Moslem religion today is integrated into traditional African culture, and that gives a special kind of character to the region. I'm a member of the Mouride sect, and we have refused to become acculturated through religion into the Arab culture. Instead, we have adopted the principles of the Moslem religion into our own culture. So though we are Moslems we continue to live our own culture. Which means that our way of seeing the religion is different, and has become a special thing in Islam.

TM: When was independence for Senegal?

MD: It was in 1960. My region was very rich. And when it came to song, wood sculpture, theater, daily life, initiation, and things like that, there was something very alive at the time. It's changed a little now because people from Louga have emigrated all over the world to work and try to find money. They're in the United States, in France, Italy—I met some yesterday here [in Venice]. In Spain, in Japan. They're everywhere in the world. But the problem is that Louga is a very special kind of city when it comes to a social hierarchy, and a cultural one. Because it has preserved a lot of different castes—griot castes, leather workers, blacksmiths. And there are people who don't belong to a caste.

TM: When you talk about castes, are you talking about inherited professions?

MD: Yes, from generation to generation. In Louga, the castes are in place, and play a very important role in life, especially in public events. They give a particular character to Louga.

TM: Who are the noncaste people?

MD: The noncaste people were born in families that were royal, and those who surrounded the royals. They are people who live among the population, but don't live like rulers anymore, like royals or dignitaries, but they still live a life of status in their social milieu. Even if they are poor, they are still respected. There is a sense of superiority and inferiority because noncaste people give alms to people of caste, material alms. Noncaste people are high prestige, caste people are low prestige.

TM: Are most occupations inherited?

MD: Caste professions are inherited. This whole situation is very important in regard to my sculpture. My father always refused to let me practice the profession of woodworking, since in Louga that is a kind of work done by caste people. And caste people are the most inferior in the social and cultural hierarchy.

TM: Are you from a noncaste family?

MD: Yes. But I have five friends who are from the woodworkers' caste. I was in the same class with them in primary school in Louga. Their fathers sold firewood to cook with. The work is very rough and hard, but it is a thing that always interested me. One of the sons had a big square in front of his house, and he sold wood there. I was always hanging around there and helping to cut wood with an axe. And finally I became very good at it. But my mother didn't like seeing me in a public square performing a caste activity.

TM: Your working with wood was conceived as degrading?

MD: Yes, exactly, very humiliating. To the family it was something that I shouldn't do. My father said nothing at first. He thought it was just something I would get over. My father was an accountant, but he also had farms and worked the land himself. He was very good at manual labor, and he did it very well. And he had a very high opinion of me at that time and did not want me to disappoint him. But despite him, at the end of primary school I left Louga for Dakar to go to art school.

TM: At what age did you leave Louga?

MD: It was in 1966, and I was born in 1952. Fourteen about. I was very stubborn. Very. If I had something in mind to do, that was it. There is a center of crafts in Dakar; you learned sculpture, jewelry, saddle-making, ceramics—there were all these sections.

TM: It was an artisanal school rather than an *école des beaux-arts*?

MD: Yes. Later I went to the École des Beaux-Arts. But when I went to the artisanal school the training was to make craftspeople, makers of furniture, decorations for the home, things like that. We had a professor of drawing, a professor of technique, a professor of math, of French, of literature, and also a studio professor.

TM: What literature?

MD: French history—not art history, but the history of France, because France colonized Senegal. And French literature.

TM: Victor Hugo?

MD: Yes, all French literature. "Our ancestors the Gauls. . . . " I had that in my textbooks. Textbooks all through French Africa began with the phrase, "Our ancestors the Gauls. . . ." And that became like a rallying cry for all that was wrong with the colonials.

TM: How do you feel about the idea that the French are your cultural ancestors?

MD: The French always tried to acculturate me—I mean, to show me that I have no culture, and that French culture is culture. Understand? My African culture is not a culture. My problem is, throughout this period of my life I was completely revolting against that. So much so that in school I slept during French literature class. It was a Guinean professor who taught me French literature, but I always slept in his course anyway.

TM: And the professor of drawing, what models did he use?

MD: He took African statues in general, not Senegalese in particular, to give us a model to draw from.

TM: While in school in Dakar, did you encounter the names of any European artists, or develop any recognition of them?

MD: No. I didn't even know there *were* European artists, because I came from Louga, which is 200 kilometers from Dakar, and I was very young. I arrived in Dakar, was always with my family, always stayed with my father's older brother. He is a businessman, art didn't interest him. So I was in that kind of atmosphere. When I finished the three-year course, I left, but I wasn't satisfied. At that time my father thought I should at last have gotten over it, and wanted me to go to accounting school.

TM: The artisanal professions taught at the school were caste professions?

MD: In the school they weren't regarded as caste professions, for the school was very French. But in cultural life out in Senegalese society it was considered that way. There are only artisans, and artisans are usually caste people. And caste people continue to accept their place. And that's the problem. But I refused to study accounting.

TM: What specialization did you graduate with?

MD: Sculpture, meaning wood-carving and decoration.

TM: The other students studying wood-carving, what would they go on to do?

MD: Some of them gave it up and went on to other studies, some work in banks and other places. But some of them continued in that line of work and became artisans, decorating furniture, which they still do. They are workmen.

TM: So the profession of artist was not differentiated from that of artisan.

MD: It was not completely defined in society in general. The artist and artisan at that time were one, were the same. It's like in traditional Dogon life, the artisan is the artist. It was the kind of work that was completely inherited and wasn't open to everyone. But today, lots of artisans give up their caste professions if their line of work has become very poor, because it hasn't been renewed to adapt to the evolution of society. People give it up to become traders.

TM: In the years since you graduated, has the profession of artist become more distinctly focused?

MD: Yes, now artists have their place in society in Senegal.

TM: There is an Académie des Beaux-Arts?

MD: Yes, with sections on sculpture, painting, and ceramics.

TM: And in the section on sculpture, do they teach conventional European-derived representational sculpture?

MD: Yes.

TM: They don't teach the type of work that you do?

MD: No. Not now.

TM: When did you develop this line of work?

MD: I've been doing it for about four years. Five years ago it was different. I did a lot of things that are so different. I consider that I've lived through three or four, maybe five stages of sculpture in the last twenty years.

TM: Can you briefly describe what those stages were?

MD: After my studies in the artisanal, I was unemployed for two years because I had nothing to work with. My family would not help me. I was without the tools to work. Then one day I really wanted to work. I went back to the artisanal school and I stole three chisels. I took the three tools, I put them in my jacket, I talked to people, and I left.

TM: What then?

MD: In 1973, I went to the Gambia, and there I worked. I couldn't stand Senegal anymore because of my family. They put a lot of pressure on me.

TM: What kind of work did you make in the Gambia?

MD: I did bas-reliefs in wood.

TM: What was the subject?

MD: Daily life in general, people eating in families, people eating around a bowl. I would take a piece of wood, I would carve a kind of bowl or calabash out of it, and in the bowl I would make a woman's head.

TM: This was a genre that already existed, that could be found in the stores?

MD: Yes.

TM: When you were doing the reliefs, did you think of yourself then as being an artist rather than an artisan? What word would you have used for your occupation at that time?

MD: I was just someone who came out of school and wanted to do things. But who didn't have the possibility of doing much. I was very curious to see things but didn't have the means. And I didn't have anybody who could help me. I didn't even know that an École des Beaux-Arts existed in Dakar. So I spent a year in the Gambia. Then I came back to Senegal. I didn't want to stay in the Gambia anymore because the Gambia was hard for me, really hard. I had a lot of trouble there. First of all they speak English, which I never learned. I sort of got by with Wolof, which is my first language. With this limitation I couldn't communicate the way I wanted to, so I returned to Dakar. I wanted to do an exhibition in the Gambia but I dropped it because it was so hard for me there.

TM: Where would that exhibition have been, in a gallery?

MD: No, there are no galleries in Gambia. The country is full of tourists, so I wanted to show what I was doing in the city in order to be able to sell what I was doing. So when

I ran into the minister of culture of the Gambia, I explained to him. He told me that unless Senegal made a request that I exhibit there, they wouldn't even let me show my work in the marketplace.

So when I got back to Senegal I went to see the director of patrimony, who was someone I knew; he did a paper for me so that I could go exhibit in the Gambia. But after I stayed in Senegal for a while, I had no interest in going back to the Gambia.

TM: Would this paper have enabled you to exhibit in the market?

MD: The administration would have told me where to exhibit, because there are no museums, no galleries, nothing like that. It could have been in a bank or a hotel, but it would have been the government who would tell me where.

TM: Was this 1975 when you returned from the Gambia to Senegal?

MD: 1974. I called up my big brother and stayed with him for a while. Then we quarreled. I took my baggage and left to stay with a friend. I was free. And I worked in my friend's place. I stayed there six, seven months, then I went home to Louga for a while. Then I came back to Dakar in 1975.

At the time I had two Gambian friends who wanted to go to Denmark; they would go by road to Egypt and take a plane from there. People did that at the time, through Mali, Burkina Faso, Niger, Nigeria, and up. I didn't have the means to do that, but I took steps to get a little money and I took the train with them. We went as far as Niger but couldn't go on because we didn't have visas. So we came back to Burkina Faso and there we decided to go to Ghana, because the Gambians were English-speakers and they don't need visas for Ghana. So I went with them. In Ghana I had visa problems, but we arranged with people so I could get in. I had a forty-eight-hour visa. I arrived in Ghana, in Accra, and was completely overcome. I didn't understand English, so I couldn't speak to anybody. I had no money. One of my companions got a ticket to go to Denmark. He left the other one and me. The other one was my friend. So we stayed in Ghana, in Accra, which is a big city. One day we went to the Senegalese embassy and luckily I found a friend there of the husband of my aunt. So we talked and talked and he gave me a little money. I bought wood with it. They were holding our passports at the hotel because we had not paid the bill, but I had my tools, so I bought wood in order to be able to work.

TM: So instead of paying at the hotel you bought wood?

MD: We had discovered a workshop. In Ghana there are sculptors who do doors with decorations of scenes of daily life on them, it's a Ghanaian tradition. My friend had discovered this workshop, I talked to the guy, who said, I'm going to give you a piece of wood, and you work on it and I'm going to see what you do. So I did this thing, he found it good, so I gave it to him. They took me in. He said, "Here is a place you can work, any time you want you can come and work here."

When I did that work, I went to the embassy to show it to the friend there, and I explained that that was what I did. He said, "I'm going to Senegal in two days. I'm going to buy this piece and give it to the minister of finance in Dakar." Then he introduced me to the ambassador. When the ambassador saw the work, he wanted to have one right away just like it. So he gave me an advance and I started to work. I delivered the piece to him, he

introduced me to everybody in the embassy, and people began to give me orders. That's how we could finally pay the hotel. I worked a lot, doing women's heads from which I could make a lot of money. That's where, for the first time, I started to do busts in bas-relief.

When I came back to Senegal after that, I was sick. I went home to Louga and they took care of me, took me to a traditional healer. I began to work there, and after two months there was a festival, a youth festival in Dakar. It was the first year that Louga was considered a region. In Louga they chose me to go and exhibit in the Louga stand at the festival.

TM: Why did they choose you?

MD: Because I had done things that were new to them.

TM: What really interests me is that you knew you had talent before you knew what art is.

MD: That's true. I had something in my hands, I knew how to do things before knowing what they were going to be. I knew I had the capacity to do a lot of things. I didn't yet understand what art was at that time, but I had an ability that allowed me to start anyway.

TM: Did you already sense that you would become an artist before you discovered that it was an actual fact?

MD: Yes. Now I feel that I could never have been anything but a sculptor. Now, if I analyze my past, the way I struggled with my family, the way I endured a lot of difficulties, the hardship that I lived, almost eighteen years of difficulty—I only had hardship because I was so stubborn.

TM: So back in Dakar in 1976, you discovered the École des Beaux-Arts.

MD: During the Louga presentation at this festival, I discovered the École de Beaux-Arts, because there were artists from there in the festival. I ran into the director of the École des Beaux-Arts, and the head of the sculpture section of the École des Beaux-Arts, and the head of the ministry of culture. They were all there visiting the different booths. And they asked me if I was the one who had made those things. So I said, Yes, I was the one. And the minister asked me, Do you want to go to the École des Beaux-Arts? He said, You can have a scholarship. You won't be considered as a student but you'll be taken as a sort of intern. I would be accepted at a more advanced level because I had already demonstrated that I could do something even the students didn't know how to do.

TM: What exactly were the works that created this reaction? Were they the bas-reliefs?

MD: No, a composition, a group of figures in three dimensions.

TM: What was the subject?

MD: Suffering, suffering.

TM: Are the figures attached to a main core of material, like Michelangelo's slaves?

MD: No, not the slaves. I saw them in the Louvre, in 1980, but no, not like that, more rustic. And I burned them also. At this time I had begun to do that, spontaneously burning and rubbing dirt into the wood. I made a big fire of wood; I put the piece in it and I rolled it, turning it as it burned. There are some woods that have a kind of yellow, and the yellow is very bright. I needed to break the color a little.

TM: Is this burning a part of traditional sculpture or was this purely an intuitive discovery?

Opposite: *La Dame au long cou* (The lady with the long neck), 1992
Wood and iron
203 x 100 cm.
Collection of the artist

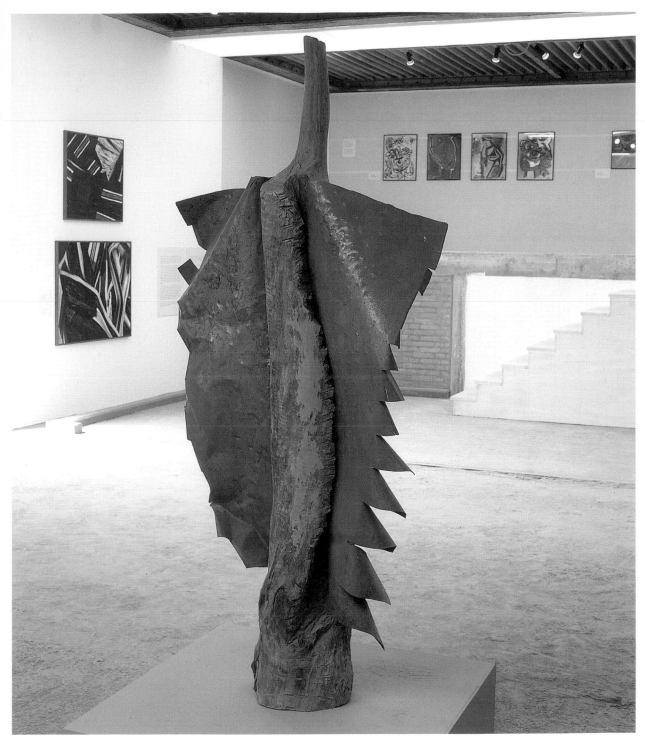

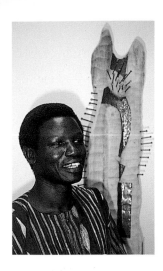

MD: I consider it an intuitive discovery, because I never learned it anyplace. Traditional sculptors don't do it. What traditional sculptors might do is take a knife, heat it until it is very hot, and just touch the wood.

TM: So these works gained entry into the École des Beaux-Arts—and then?

MD: I was there for a year. But after a year, my professor told me, You've already learned everything, you've learned the essentials. Now the only thing to do is to try to develop your spirit, your mind, to learn how to compose and create.

TM: What type of work did you make that prompted your professor to say this?

MD: I had begun a sculpture in Louga, I brought it with me to the École. It was a kind of statue, a beggar who was sitting in the street with his hand out.

TM: Life-size?

MD: About.

TM: Any added paint?

MD: No, just wood, and I left the color like that.

TM: And after the year at the École des Beaux-Arts?

MD: Then I began to realize certain things, began seriously to learn, and to associate with traditional sculptors, to learn their technique with an adze. In school we were taught to use the chisel, because our studio professor was French, from Marseilles. But when I began to set out on my own, this really disgusted me. The adze is of course the traditional African tool. I said to myself, The best way to get your own balance is to immerse yourself in what people do in traditional African art. And I began to buy adzes, and to work with them. I learned that the adze is completely different from the chisel, that its material structure is completely different from the chisel. Two kinds of difference: a chisel is like percussion, it's struck, it's a cutting thing you hit. Whereas the adze, in a traditional milieu, is thrown, or stroked.

TM: So there is a real cultural association with the tools: the chisel represents the West, and the adze represents Africa.

MD: That's true. When I understood that, I said to myself, I have to learn to use the tools of my own culture. I had a little money to buy the other tools of my trade.

TM: What happened to the three chisels you stole from the school?

MD: I still use them. They are with my tools today.

So in 1977, when I began to understand all this, I was under a lot of pressure, and I drank a lot. I was a real drinker—beer, wine—and I needed money all the time for it. My professor told me not to waste all my time in school. From time to time he gave me work to do; I would do it and then go away. For fifteen or twenty days I'd do decorations, it gave me money.

TM: With the chisel or the adze?

MD: With both. But mostly with the chisel, because these were French decors, a very precise work, and I know how to use it very well.

TM: During the year at the École des Beaux-Arts, did you become familiar with the work of any European artist?

MD: Not exactly, because the professor who taught me was half Belgian, half Senegalese.

He was born in Belgium and studied there until 1966, when Senghor [then the president of Senegal] brought him back.

TM: This teacher's orientation was toward figurative sculpture?

MD: He had models of European sculpture in general. Classical sculpture, that was in ancient temples. But you have to know one thing: I had vomited acculturation, and even while I was at the École des Beaux-Arts I didn't want any of that. I didn't want to look at catalogues, books in the library, or any of that, it didn't interest me at all. It was maybe through all of these frustrations that I began to drink to a catastrophic degree. I knew what I was doing wasn't good, but I couldn't stop.

TM: So the year in art school was followed by a year of profligacy?

MD: More than a year. It continued until 1983 or '84. Then I stopped. I think maybe it was the frustration: my whole generation was working, they had succeeded in the social milieu. I was the only one who didn't have normal resources. I was practicing a caste profession and I wasn't accepted, I was marginalized. My father said I was the most failed of all of his children. Every time he talked with people he would say that. And if we met, right away we would quarrel, because he would say things I couldn't accept. And so I couldn't stand it, and I would tell him right away, even though that is not accepted in our milieu. In our milieu, even if your father insults you, even if he hits you, you should do nothing. But I have the same character as my father, which means that it's a little hard between us. And also, Moslems don't drink, so that's an added thing. It's not accepted, if you drink you are marginalized for that.

TM: Around 1983, what ended this period of frustration and drinking?

MD: Maybe I'd had enough. And I was working a lot at that time. I exhibited in December 1979–January 1980, in the French Cultural Center in Dakar. The title of the show was "The Face of Senegalese Sculpture."

TM: What was the work like?

MD: We had all just come out of the École des Beaux-Arts except for one. He did stone sculpture. I only did wood. There was one who worked in iron. Another worked on plaster around an iron armature, mixed with string.

TM: Was that figurative work?

MD: No. It was more or less abstraction. Only the stone sculptor did realistic work.

TM: When you say abstraction, do you mean geometric abstractions based on traditional African forms?

MD: No, they were were more or less modern, it had nothing to do with tradition.

TM: Based to some degree on Western models?

MD: No, not exactly, because these were things that each artist wanted to imagine for himself. Each wanted to create his own originality, his own style. That's what pushed people to try to create their own designs. One of my own biggest pieces was a kind of totem, with a trunk of a tree about 2 meters 30 in circumference. I created heads of social outcasts—bums and beggars. I tried to show their faces, how they really are in life, and I did sort of superposition or layering of them. I called it *Hope*. At the base of the sculpture was a person with a deformed body, with two feet on a head, and he carried the rest.

TM: Why did you treat the theme of marginal people?

MD: Because I was marginal myself. And because at this time, on a political level in Senegal, Senghor had said, "In public, I don't want to see any beggars, because of the tourists." That was published in the papers, and right away I started working on that. And I did a lot of things in that vein, even afterwards. This exhibition was the thing that produced my meeting with Senghor. I had said on television that the Senegal ministry of culture wasn't worth a thing as a political or cultural body. Because when we needed them we never saw them. The French put this exhibition on, the Senegalese did nothing. I was furious about that. And a journalist said, "Whatever you say is going to be your responsibility. Everything is going to be published. Everything you say, you're saying yourself. I don't care what you say, but it's your responsibility."

They showed that on television and the minister of culture was furious. He summoned us to his office, we met the director of arts, who is now retired. He said to us, "What you said on television, you're fermenting trouble. You have to go back to the television, today, and ask to be excused, and beg the ministry of culture for forgiveness." I said I would prefer to give up art forever rather than go on television and do that, because what I said is what I believe. And today I would say it again louder. Two days later we met the minister, and the minister said, "You're all liars. I turned my television on and I saw young liars who said things that aren't true." I stood up and said to him, "*Monsieur le ministre*, if you tell me things that are rude, I will reply in kind. Because my father, I don't even let him say rude things to me." So we quarreled seriously.

A month later, Senghor invited all the Senegalese sculptors. I had sold another piece to the Association of Architects, and they gave that piece to the president. So when he received us—I have this in a photograph in the newspaper—he had put my piece next to a work of another young sculptor, and two other Zairian sculptures, traditional ones, to show traditional compared to modern sculptures. So he considered my sculpture modern, and he said it in front of everybody. And he asked me to explain my work. And the minister of culture was there so he was furious up to here, furious. Senghor went on and on, gave a whole lecture on art, because he was a professor at the time. After that they left us there with the minister, to have a meeting. He began to attack us again. And we threw words at each other. A month later, I had written a letter to Senghor, and he received me for an audience. I stayed thirty minutes in his office. We talked about art and everything, he even suggested to me that I should have a scholarship to study in France.

But at that time my preoccupation was to make study trips in Africa, to see sculptures in Africa. And so I made a request to the ministry of culture, asking to go to Dogon country in Mali. Senghor had written to the minister of culture telling him to give me a grant of 300,000 francs (about $1,000) for two months to go up to Bandiagara. So I went there. And Senghor chose two of my sculptures in a national group show that same year, and I sold both. So that made a huge success for me in the artistic world.

TM: What were they like?

MD: They were "filiforms," stringlike. Those tend to be very openwork, figurative and fantastical, a little bit like the Makonde things you see. Very smoothly finished, very virtuoso

in workmanship. When I worked in that style, I did it so well that it surprised me. Each time I worked in that style I was feeling farther and farther along, and I worked a lot. In those years I worked a lot, I worked enormously. I really wanted to say things.

After that year I went to the Village des Arts in Dakar. That was a village created by the artists because Senegal wanted to create a *cité des arts*. But in the end it never happened. We finally preferred to create one. I had a studio there.

TM: Who's we?

MD: The artists in general—painters, sculptors, etc.

TM: What was your studio like?

MD: It was a big studio. Inside there was a bathroom, and I had built a mezzanine in it to sleep up there. This is where I worked. Each person had his own space. Fode Camara had a studio there too.

TM: At a certain point in your development as an artist you began recycling materials, or using found materials.

MD: It is something I started to do from the time I lived in the Village des Arts, and wanted to leave behind what I was doing. Because it had become routine, I had done too many of them. There were no secrets left in that work. I would take a piece of wood like that, I would work it from one end to the other, I would create forms, movement. Finally it didn't interest me anymore, because there was no tension left, no life.

TM: How did the transition to using found objects happen?

MD: The Village des Arts is next to the sea. So often I took stones from there and worked the stones. I also used oil paint and painted a lot of wood. And I also used iron and ropes.

TM: But the wood and the iron already had a past, had already been used in some way?

MD: Not necessarily. I still carved and integrated other materials that were not used. The

iron was recycled, but also I would go into factories and woodcarving shops to take wood that people weren't using, wood that might have machine traces on one side and the other side might be raw, natural. So I took that kind of material and made compositions with it.

TM: In your use of materials that had already been used formerly, was there a sense that this was a way to plug into the life of the culture?

MD: No, not yet. I had a different view then, which was to have access to natural

materials—materials that, from the point of view of the material itself, had particular qualities to it. But not because it had been used. I was searching for something that belonged to me.

TM: What would show that it belonged to you?

MD: I was looking for what would articulate my personality, would permit me to show myself, my own personality, what made me different from others. Not in the themes but in the technical subtleties.

TM: This is practically the definition of the full realization of the idea of the artist, isn't it?

MD: Yes.

TM: Well, go on.

MD: When I was in Mali, I had learned bogolan (mud-resist cloth with geometric designs). So when I came home I tried to do things that were based on bogolan. Then I did an exhibition in 1982, my first one-man show. I showed about thirty sculptures and four bogolan cloths, big ones. People really liked it but, unlike the group shows, I didn't sell a thing. It so discouraged me. I thought, If they liked it they would buy. There were people in government who bought, people in businesses who bought, foreigners also buy, and the ministry of culture bought. So that was sort of the market.

TM: What did the ministry of culture buy for? Was there a museum in Dakar?

MD: Yes, since 1966. It had opened for the World Festival of Negro Art, and was destined for that. Afterwards important people in the world exhibited there. At various times there were different international exhibitions—Iba N'Diaye, Picasso, some French artists.

TM: Did you see these exhibitions?

MD: No, but I saw the catalogues, and I heard people talk about them.

After the show, when nothing had sold, to bring the work back to the studio, I had to have a friend help me with his car because I had no money. I had no sponsors, I had done everything myself, even the invitations, everything. So to sell nothing, you can imagine what it had done to me. Finally I wanted to throw it all out, do something else entirely. This was 1982. I said to myself, My father is right, I can't make even one franc from what I'm doing. It gave me a crisis for some time, I couldn't work. I just wandered around, I didn't know what to do. Until I came back to myself. Then I started to work again, and I took part in events in the Village des Arts. Others in the village were organized, and from time to time they made exhibitions and had events and invited the public. All the artists would be there and the public would come.

Two years later, the state wanted to take back that place to turn it into the ministry of buildings. An artist friend of Bara Diokhane, the lawyer, had wanted to do a retrospective of one of the people who had opposed Senghor and who had been killed in prison. Some weeks after that, they told us, "That's it, out." But the artists did not want to honor the departure order, they wanted to stay. The state waited until the president went on a trip. Then the minister of culture came at five o'clock in the morning, circled the village with repressive police, and at seven o'clock in the morning they broke open all the doors, took all the works, put them on pushcarts and pushed them outside and left them there. They put all the work of everybody on these carts. I lost about seven sculptures. We stayed there

a week, camped outside, and slept outside.

This Village des Arts was between the corniche and the sea, and we took the sculptures and paintings and made an exhibition along the corniche. Then people went by, asked what was happening, we explained, and they took advantage of the moment to see what we were doing. And the state said that in the village people were taking drugs and prostitutes were there. We fought about that. A week later, they came with trucks, they took everything and carried it away and put it in the cellar of the museum, which is near the sea, they put everything there.

Finally we had a meeting and took on the lawyer Bara Diokhane, who was supposed to defend our case. At that time they had to evaluate all the works that had been carted out. They were all broken, and there was no expert in art in Senegal who could evaluate them. They wanted to find an accountant to do it, it was like a joke. Finally I had had enough of all of that. With two friends, I rented a house in Dakar, and I've lived and worked there ever since.

TM: So you are now more accepted in Senegal and not such a rebel, not such an outlaw?

MD: No, I'm not such a rebel anymore. I'm more spiritual now, because since then I've become more interested in Islam, and I've also become very interested in African culture, including my own origins. I travel a lot in Senegal, to the different regions.

TM: In the mid-to-late '80s, how were you paying the rent?

MD: Sometimes I could go a whole year without paying the rent. If I sold one piece then I could pay. Even today it is like that.

TM: Would such a piece be sold to a foreigner?

MD: I've sold a few pieces to two or three French people, but all the rest I've sold to Senegalese or to the state.

TM: Is this your first visit to Europe?

MD: This is my third voyage to Europe. In 1990, I was invited to a festival in Toulouse. Each person was to make a studio. I had one in the museum in Toulouse. I made a sculpture there, which is still there, they still haven't paid me. They said they would but they haven't.

Also in 1990 there was an exhibition of contemporary Senegalese art at the Arche de la Défense, in Paris. And I was represented there.

TM: I feel still uncertain about when your work entered its present mode.

MD: There were a lot of transitions leading to this. The "filiforms"—I came back to that style after 1982. After 1983 I came back to that style again, but in a different way: I started to make them very, very, very thin, and more human, more polished. I worked the wood in such a way that if you touched it with your arm it would just slide, it would be very smooth. I wanted people to want to touch it.

TM: But now your work is rougher, more rough hewn.

MD: This work has nothing to do with the other. What pushed me also to leave that style was that there is a Senegalese sculptor with whom I exhibited in 1990 in the Senegalese exhibit in the French Cultural Center. He had a scholarship to Carrara, and he worked a lot there and came back to Senegal. He wanted to do something that had nothing to do

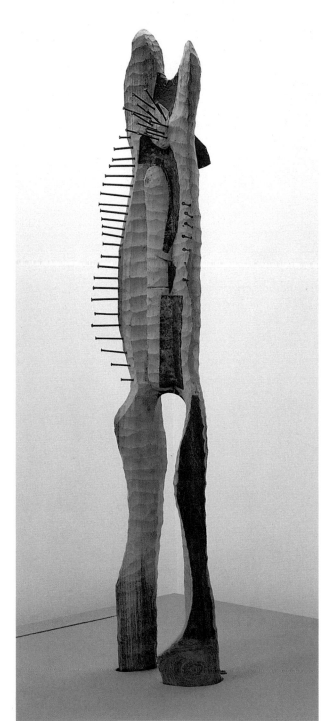

Mémoire totémique (Totemic memory), 1992
Wood and iron
227 x 44 cm.
Collection of the artist

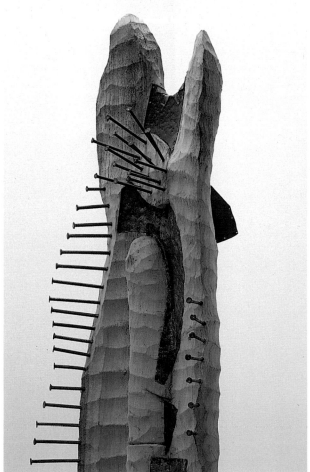

Femme sérère (Serer woman),
1992
Bowls, mortars, and pestle
145 x 49 cm.
Collection of the artist

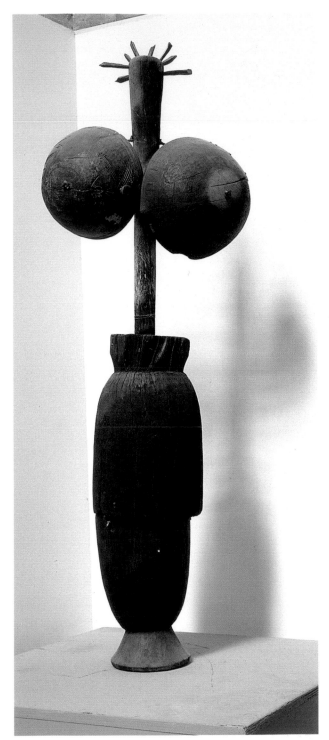

with what he had done in Italy. He hung out with me. We would talk. I'm older than he is. A little after that I realized he was now doing the same thing that I was doing. We had an exhibition of Senegalese artists against apartheid, and the sculpture he presented there looked a lot like mine. And everybody said that.

This so revolted me that I had a year-long crisis. I couldn't do anything different from what I had been doing, I was so disheartened and furious. I couldn't work. That guy, that is what he is still doing today. But even today, people consider him a craftsman, not an artist. That's why I started to think and think. And finally I started to do this thing with recycled materials. I have to use material that allows people, or that leads people, to be closer to their own life. Before Senghor, art was completely cut off from society in Senegal. Only people who had gone to school, who were in the administration, only they went to exhibitions. You have museums, galleries, cultural centers, all made for intellectuals who are the elite, not for the people at large. It is very important for me to use materials that don't alienate the society where I live.

TM: Materials that come from everyday life?

MD: Very right.

TM: And also materials that have a life, an anterior history of their own?

MD: Yes, they have lived in the environment. There's no difference between these materials and people.

TM: So they are a connection not only with people but also with the environment, the reality of the continent, of Africa, of African culture?

MD: Exactly. Considering the level of development of Senegalese society, I think you should try to reach the whole population, to let them all reeducate themselves on an equal level. I am trying to do that, I know it's a difficult work, very, very difficult. It's been two years since I've been slightly satisfied with my own work, since I've begun seriously to make sculpture.

TM: So it seems to me that your work, in your mind, may serve at least two functions. On the one hand there's the expression of your sensibility and your sense of your selfhood and the realization of your selfhood, and on the other hand there's the project of integrating art into society in Senegal, in the sense of affirming the wholeness of everything, of life in Senegalese society contributing to that wholeness.

MD: That's my deepest feeling. I want to tell you a story. In my room, there's a sculpture with three bowls, one on the top of the other, and the base is a mortar. An 80-year-old Serer man visited. This is Senghor's ethnic group, and these are people who up until today have jealously conserved their traditions. When he saw the sculpture, he threw himself on it, because his generation and his family were very close to the king of the Serer before independence. And up until today these are the people who continue to perform this kind of ritual. They do it with a mixture of gum. It surprised me so much.

TM: What do you mean he threw himself on it?

MD: He physically threw himself on it, and laughed. And he gave it a name. This name, I don't know what it means, but he talked to it, the sculpture. And he said, "Moustapha, now I know that what you are doing comes from your soul, because there is a communication

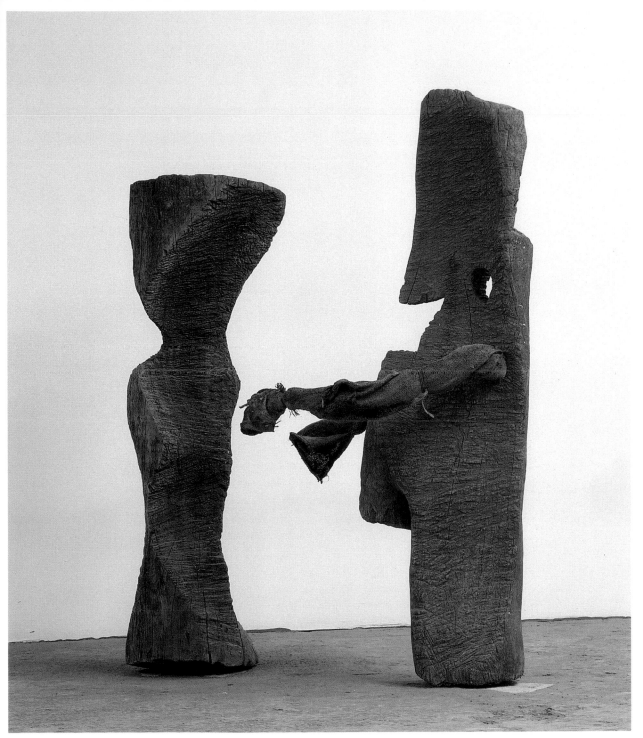

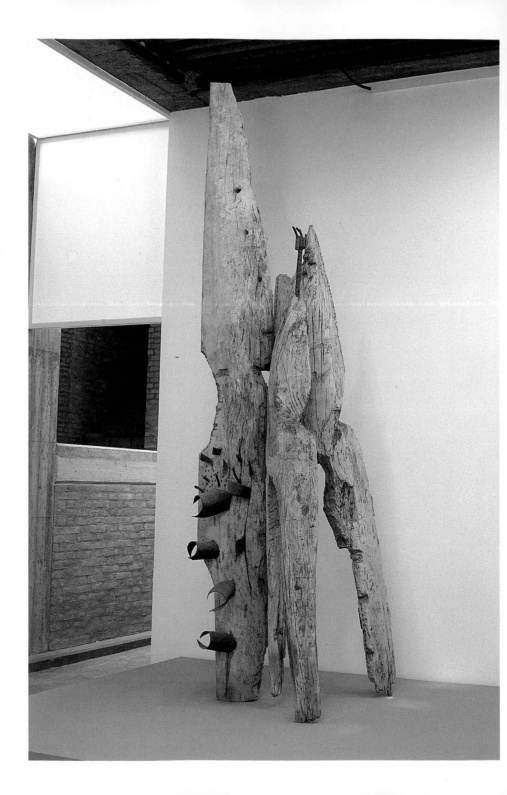

between you and other people." That's not the end of the story. In my exhibition in 1992, I showed that same sculpture and a Diola, a member of a different ethnic group, came and when he saw it, he went directly to that sculpture, he looked at it, and he was talking to it. He came and asked who made it. I said I did it. He said to me, "Can you come with me for two minutes?" I went with him. He asked me what I meant by that sculpture, what emotion had pushed me to do it, what I wanted to do? I gave him my explanation. He said, In the Diola religion, in their concept of the universe, there are three dimensions—the world of men, the world of spirits, and the world of god. Nature also has its place. The symbolism of the mortar and the bowls is the fundamental basis of life, because that's where you transform the element of life, meaning food, millet. So for them it was their universe. I have his address with me, this man.

TM: I have the sense that Dogon civilization means a lot to you. Is this in part because of the emphasis Cheik Anta Diop put on it?

MD: Surely, and it's also because at a certain moment I had an identity crisis, since I was in a French school, and I spoke French so much that I threw my own language away. So at a point I had to vomit it all out, to be really African, to be really Senegalese, in my own culture with all of its values. I put a lot of effort into it, until I arrived at a point where I even spoke French badly. I began to relearn my own language and to associate with people who speak Wolof very well. And now I can speak it so well. It pushed me also to do a lot of research on the cultures in different parts of Senegal.

TM: Would you describe yourself as a practicing Moslem?

MD: I'm Moslem but not practicing like the Moslems who go to the mosque every week. No, I don't even go to the mosque. But for me sculpture is a form of practicing Islam. When Islam first came to Senegal, the Moslems destroyed Senegalese sculpture—anything related to sculpture they destroyed on the basis of the Islamic prohibition against figuration. But I think that is a shallow interpretation of the Islamic text, because God created visual beauty in the world. And there is nothing more beautiful than a work of art, so the work of art is very close to God, and should be a part of God's sacred text, not a part of that which is destroyed for the sake of that text. Also, for me in religion we have someone whom we consider as a spiritual guide, who's done a kind of African synthesis of the Moslem religion. And the essential of this is in your heart.

TM: Who is this guide?

MD: Sheik Amadou Bamba, who is the spiritual guide of the Mouride sect. Bamba was a Senegalese who founded the sect and who was exiled by France to Gabon for seven years, so he was considered a national hero.

TM: Have you, here in Venice, had an opportunity to walk around and look at other exhibitions? Did you happen to see the exhibition of Louise Bourgeois's work?

MD: I saw her work yesterday. It's one of the best exhibitions in the Biennale because it is full of humanity, I feel that there is a human being there. Because I consider that art is the soul of a person; it's not just taking material and working with it, it's the spirit that comes out. Because it's the spirit that needs to say something, the spirit that needs to give something of itself to others. I really felt at home when I walked around her exhibition, because I

Opposite: *Les Hommes de Kayar* (The men of Kayar), 1992
Wood and iron
335 x 92 cm.
Collection of the artist

really felt the presence of a human being. It was not just something for commerce, but a kind of gift. That's the way it should be.

Everyday that I see you, I try to approach you because I want to give you things and I want to take things from you. I consider that the world is like that. In my way of seeing things, I consider that we're here, we human beings, to give to one another, not to just take or to amass money. Each person can show generosity and give to another.

TM: I think your work embodies this idea.

MD: I think so, because if I don't feel it, I can't work. If I don't feel the necessity, I don't work. Since I've been born until today, since I've been conscious of what I did, I've never done anything but sculpture. And I don't feel the need to do anything but sculpture. And I don't want to do anything other than that. You want to make money to live, but you accept not having any money, and you keep working because you really want to do what you're doing. It's not a question of freedom, because to me it is not a freedom. it's a question of necessity, because you really have a need to do something that's part of yourself. And my equilibrium today is in sculpture.

TM: I feel that in the near future, Africa, Europe, Asia, and the Americas will collaborate in a new kind of a cultural project for which I think that art right now is finding the basic vocabulary.

MD: Yes, I know that it's going to happen. I tell you what, you know why it's behind schedule, why it hasn't happened yet? It's because the economy and politics in the world, that's what's holding us back. If it were just up to artists, we would have settled things long ago. There wouldn't be a crisis.

TM: Now as we talk I see the spiritual meaning of your work as involving not two but three layers—first of personal sensibility and self-realization, second of Africa and the idea of the integrity of the Senegalese heritage, and thirdly this sense of participating in a global project that involves other artists of other cultures also.

MD: I think you're right. Even though I was born in Louga, I consider myself as a universal being.

TM: Do you ever feel tension between a universal sense of yourself and your desire to make sure that you understand your deep roots in your own culture?

MD: If I didn't succeed in keeping my own roots I could never be universal, because it's on that basis that I can become universal—on the basis of my own roots. Because that's how I've become what I am. The humanity that I am in the process of living today is born in my own roots. Maybe I would be marginalized and still in prison. Not a prison that would be locked up with a key, but the prison in myself. That's really where the drama is. And I think that the obstacles in the world today are because people don't have the possibility of a chance to free themselves from their own personal prisons. Because the question is the question of prison—having defenses around yourself that keep you from going to another person creates an interior prison. And if a person doesn't succeed in cutting out of that, he will always be desperate, what he is today. I think that's what is blocking, impeding, the world.

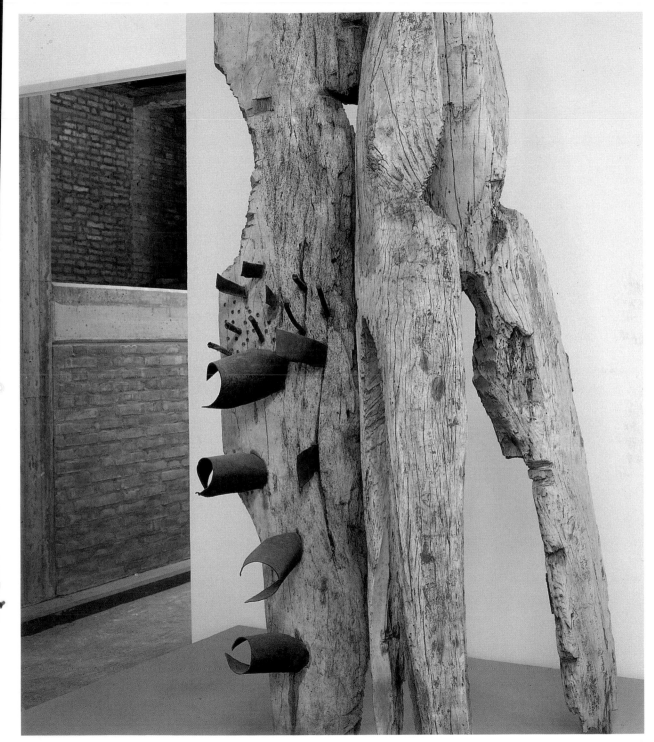

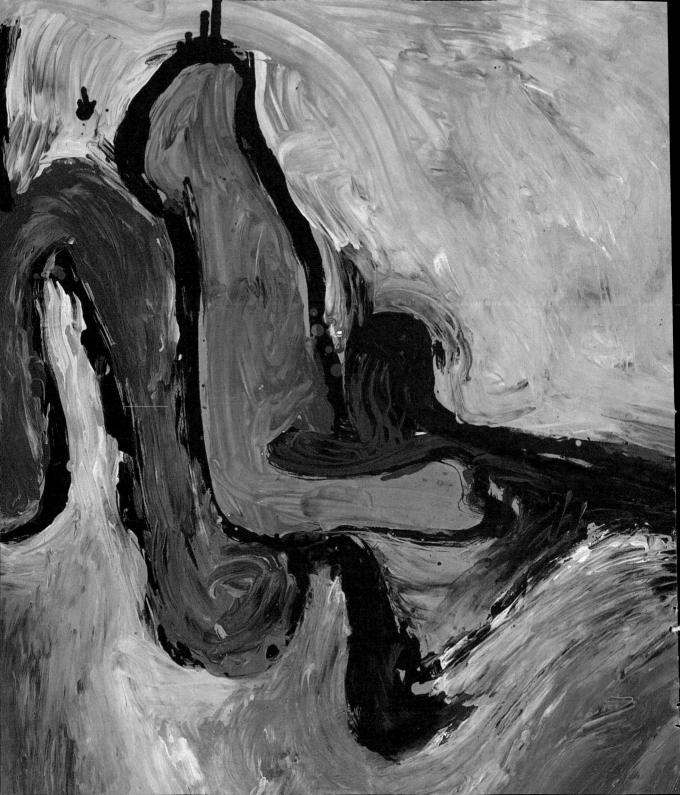

An Interview with Tamessir Dia

Thomas McEvilley
Venice, 10 June 1993

Thomas McEvilley: Am I right in thinking that you are Senegalese but were born in Mali?

Tamessir Dia: I was born in Mali in 1950. My mother is Senegalese; my father is of Senegalese origin but lived a long time in Ivory Coast. I was very small when we left Mali, still a baby, eight months or less. When I was growing up we all lived in Ivory Coast with my family in Abidjan. I did my primary-school education in Ivory Coast.

TM: Was Abidjan an urban milieu then, as it is now?

TD: No, at the time it wasn't an urban environment. It was very traditional. We had a lot of contact with everyone, with cousins, grandparents. We lived in a neighborhood, it was a community. But it's changed—now it's a modern city. We live in the same neighborhood but it's different today. People have moved from neighborhood to neighborhood and now live among people whom they don't really know. It changes every day.

TM: What was the visual surrounding like?

TD: When I was very small I was surrounded by a traditional Moslem milieu. I had a lot of aunts and cousins. I lived in the middle of what was beautiful, because my aunts were very opulent, very elegant, very beautiful. They had traditional jewelry, they went to lavish marriages, baptisms, funerals. It was a time when people were very happy. They had very few worries, or they felt that they had few worries. No one imagined that things could become the way they have now. Today people don't do opulent weddings and baptisms, except the very, very rich. Now it's very simple because of the economic problems that are everywhere.

TM: Did this decline in the quality of life accompany increasing Western penetration?

TD: Yes, of course. There was the problem of Westernization, there is a demographic problem that is a part of it, and also there is a political problem.

TM: What's the demographic problem?

TD: Enormous population growth, so people suffer now.

TM: To what is that attributed?

TD: It's due to the fact that there was no family-planning policy. People were neglectful, and had lots of children. I know someone who had twenty-five children. I tell people, Don't have any more children. But they associate having a lot of children with God, and think that God will help you have the money to support them. That's the problem.

TM: Was the visual milieu both Moslem and traditional African?

TD: Yes, traditional African, those two things were linked. In my family, we are purely Moslem. It's in the tradition of our family. But besides the Moslem tradition we have other

religious activities that are much more part of the mystical and other. They are traditional African. That's an individual matter that each person does himself. The mother takes charge of that. She'll go to a traditional African healer to take care of her children, outside of the Moslem tradition. I think that prayer alone isn't enough, so there's another means to reach God, and to have a healthy, appropriate life through mystical means. By mystical I mean traditional African. Even if you pray like a Moslem, you still go to a healer or a diviner to find out about your future, to find out about your life and what you are going to become, the future of your children and so forth. When I was very young, when I was twelve or thirteen years old, I went to find out what my future would be and what my problems would be.

I was the only son my mother had with my father, and my mother did not live with us. I never knew if she and my father didn't get along, but I don't think she lived with him for very long. She left when I was very young. She couldn't take care of me by herself, so she gave me to my father. It was my aunt who carried me on her back. She carried me on her back when she was only eight years old. I didn't see my mother during my childhood. The first time I saw her I was twelve or thirteen years old. The second time, I was twenty-four. So I was alone; even if people were good to me, I was still alone. A woman will only take care of her own child. A child of someone else, being not her child, she will not take care of it. So I knew I had to take care of myself alone. I was lucky to have around me aunts, uncles, and neighbors who understood the problem and who could lend a hand.

TM: In the visual milieu, was the Moslem prohibition of figurative images in effect?

TD: You have to understand that our conception of the Moslem religion as Africans is different from the Arab one. Completely different. We don't have the same perceptions. Except those who are eighty or ninety years old, maybe they do, but the sixty- or forty-year-olds don't have the same perceptions.

TM: So there was figurative art in your environment when you grew up?

TD: Yes, there was. For example, there were images that were scenes of hell, in posters on the streets. They were Arab. They would represent a person on a horse, who was impaled to show that this was hell. The posters were made in Saudi Arabia or Egypt. And when you looked at them there were old people sitting next to each other, a horse with wings, one or two Arabs fighting, and so forth.

And there were painters too, who were self-taught, who painted portraits of people and sold them in the streets. They weren't Moslems, or even if they were Moslems we didn't care one way or the other.

TM: These would be frontal portraits?

TD: Yes, in oil paint on cotton cloth, stretched on a wooden frame. You can still find these paintings now, sold on the streets of Abidjan.

TM: Are they made of the portrait subjects right on the scene? On the street?

TD: No, not necessarily. They do portraits of old people with hats, traditional. Old people, known people, maybe famous people. Often people the painter would see, often old people

who look right to him, and painted to sell. More often old people than young, because African people in those days accorded an importance to age. It was a whole lifetime that you were looking at.

TM: This portrait of an old person would end up on the wall of the home of someone who didn't even know this person?

TD: That's right, in the house of someone who didn't know them. But they would appreciate the realism, and the image of the old person would have something that touched them.

TM: There was a veneration for age?

TD: A respect. There were only a few of these painters. They also did countrysides, and traditional images of colonial Africa.

TM: Was there also traditional Middle Eastern–style Islamic abstraction? Decorative, geometric, Taj Mahal–type stuff?

TD: From the time I am remembering, there wasn't anything like that. People did figurative painting.

TM: What was your education like in grade school in Abidjan?

TD: I went to a regional school that was in my neighborhood, about a kilometer from my home. I went on foot with my brothers and sisters, seven boys and two girls, and my cousins. It was traditional education at home and Western-style education at school. When we got to the school we were forbidden to speak our own dialect. We spoke only French.

TM: The various languages in question are French and Wolof?

TD: No, in Ivory Coast it's not Wolof, it's Djula and Bambara. But in my family I speak Bambara, Wolof, Susu, and French. I learned Arabic when I was little, but I only use it to pray. Today there are people who have learned to speak Arabic very well.

TM: So there was this dichotomy between the traditional African education at home and the French education at school?

TD: Yes. We went to school to learn how to express ourselves in a way that would help us to succeed in the world.

TM: And was there any tension felt between these two poles of education?

TD: Absolutely not.

TM: Could you describe the traditional African upbringing at home?

TD: I lived with my brothers. We were six boys living in the same room, and the sisters lived with their mothers. My father had three wives, which meant that we were sixteen children, of whom two died. Now we are dispersed around, married with our own families.

TM: Did the three wives live in the same household?

TD: Yes, each had a living room, bedroom, and veranda. Each woman had her own part, and my father had his own living room and bedroom for himself. It was a big long house, and there were three entrances opening onto a courtyard. On the other side of the courtyard were the rooms where we boys lived.

TM: Did you function as three families or as one family?

TD: One family, because my father had a lot of personality and a lot of character, and he didn't allow any problems. He was very vigilant. Sometimes there were tensions, fights among the boys and quarrels among the girls, but these weren't something that went very

far, because our father knew how to put things in order.

My father lived with Europeans, and he had a very developed conception of things. He insisted very early that all of his children had to go to school. In the milieu of very traditional families that I lived in, they do excision [clitoridectomy] of the girls. But my father didn't want that, he was against it. He was interested in theology, and he read a lot of European writers. I remember that when I was a little boy I took books from him by Victor Hugo. He taught himself. There were even times, in marriages, baptisms, where you are supposed to spend a lot of money traditionally, and he was against that too. He was a very advanced person and the proof is that all his children went to school. I have a brother who works in the national bank, another who's an oceanographer, another who's in computer science, and one who is doing restoration work at the airport. My little sister is in business. My family had a very advanced vision of things, but still respected tradition. And I think we were very fortunate to have a father like that. When he died, we didn't have any problems with inheritance, because each one already had his own inheritance: our inheritance was that you had to take care of yourself, you had to know how to get what you needed yourself. That's what our father taught us. There were no quarrels among us.

TM: The instruction in grade school was more or less the French one?

TD: Absolutely. We read French literature. I love Baudelaire, Victor Hugo, Balzac.

TM: What was the art education in grade school in Abidjan?

TD: In grammar school they taught us how to draw, sometimes from imagination, sometimes they would give us a flower to draw. And there were drawings of maps, natural science, botany. Sometimes they sent me to the blackboard to do these drawings.

TM: Because you were specially gifted at it?

TD: Yes. And I tried to reproduce comic strips. I would draw them bigger. One day when I was fifteen, I went to the library and saw a book on the Sistine Chapel by Michelangelo. I bought a notebook and brought it back to the library to reproduce the seven images and the Creation—also other images, of women and sculptures, on other pages of the book. And I said to myself, I want to be a painter.

TM: Were you in secondary school at the time?

TD: I never went to conventional secondary school. I wanted to go to art school, but when I applied to the art school in Abidjan, they wouldn't take me because they said I didn't have enough course work. You had to have a conventional high school degree, and I didn't. So I spent a couple of years out of school, copying the Michelangelo and other things at the library. Then finally I went to the school of applied arts instead.

TM: Were you the same age as the other students there, or had the other students gone to high school and then to art school?

TD: I was younger because I had skipped high school.

TM: So your ambition to be an artist was that clear already?

Opposite: *Le Souffleur de vent*
(The windblower), 1993
Mixed media on paperboard
103 x 82.8 cm.
Collection of the artist
58

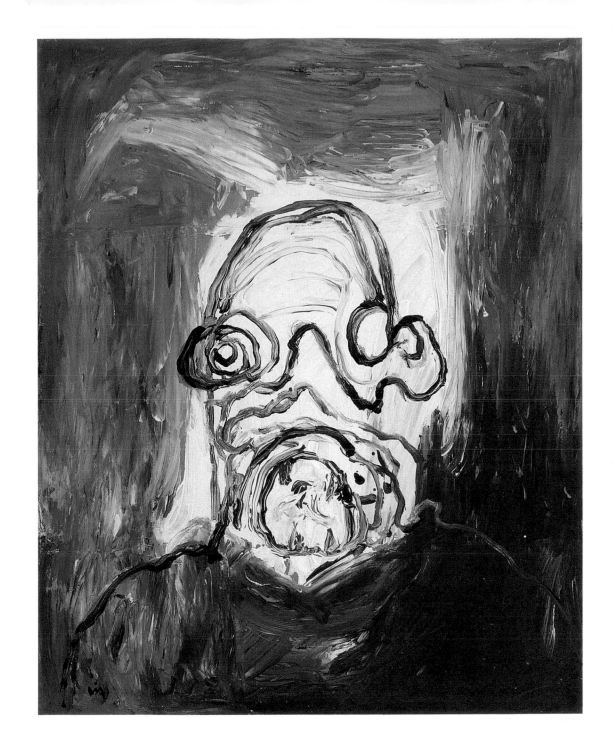

TD: I didn't want to do anything else. I started to draw when I was about nine.

TM: But the ambition to be an artist?

TD: Fourteen, fifteen, sixteen. During the years I was out of school, before going to the school of applied arts, I was taught by a friend who had gone to the École des Beaux-Arts. He taught me how to draw and how to work on an easel. He lived behind a cemetery. I would go there at night, like nine o'clock at night, and come home at midnight. After that I met another person who introduced me to someone who lived five kilometers away, and I went every day. He had gone to the École des Beaux-Arts, so he explained technique to me. Then I took my pictures and drawings and used them to apply to the École des Beaux-Arts, and they entered me into the school of applied arts, where those they rejected went.

TM: At what age?

TD: Nineteen. Between fifteen and nineteen, I didn't go to school.

TM: In addition to Michelangelo, were there other artists who inspired or interested you as you were growing up?

TD: Correggio, Leonardo da Vinci, Raphael, and the modern painters. When I was in the school of applied arts, around 1969 and 1970, we had a professor who was French. He showed us Cézanne and Matisse, but he didn't want to show us Picasso. He told us to copy and draw, and to try to understand the great masters.

Afterwards those of us who went to that school had a lot of trouble because we were considered rejects, less than nothings compared to the people in the École de Beaux-Arts. A French professor struggled to get scholarships for us in France. As I was interested in tapestry, I got a scholarship to Aubusson. The others went to different schools, to Paris.

TM: Was this the teacher who presented works of Cézanne?

TD: Yes. Also Van Gogh, Rubens, Ingres—he was an enthusiast of Ingres—and Delacroix.

TM: And then on to Aubusson, aged twenty-two?

TD: Twenty-four. It was an exile. I was the only African within a hundred kilometers. I was a Moslem, as I am now, but because I was so alone I had to go to church. Because to my conception, the Catholic and Moslem religions worship the same God.

TM: How long were you in school in Aubusson?

TD: I was there from 1974 to 1976; I made tapestry there. Then I went to the École des Beaux-Arts in Angers for a year, then I did a national diploma in Tours and had an honorable mention for research.

After graduating I wanted to see my mother. I was looking for her blessing. I wanted to show her that I had succeeded. I remember on the day that I was to take the plane back to Ivory Coast she held my hand like a child to cross the street. I was waiting for a big truck to catch the plane, and I kept saying, "Go home, go home, I'll wait by myself." But I was like a baby to her; she stayed with me and held my hand till the truck came.

TM: When was your return to Africa?

TD: In 1980 I finished school and went back to Ivory Coast. I lived in a bungalow and taught in a high school. Then in 1982 I was married to my wonderful wife. We had met in France, and when I met her, both she and her parents had never had contact with any Africans. We now have two sons.

TM: Was it during the years in France that modern art, meaning post–World War I European art, came into your consciousness?

TD: Yes. I became very interested in modern painters. But before speaking of them I should mention Delacroix. He interested me greatly because of his colors. They were very different from people like Raphael, Ingres, and El Greco. And then there was Cézanne. He was everywhere in the French museums. But the absolute most was Picasso; what he was doing made an incredible difference to me. In Picasso all of painting, universal painting, is there for me. His imagination, his creative sense, interested me a lot.

TM: I get the impression that the African tradition, the Moslem tradition, and the French-European tradition are all natural to you, that they all belong to you, and have formed you in a harmonious way without tensions and conflicts between them.

TD: Absolutely. I never felt conflicts in that way. I think people of my generation never had those conflicts. Because today people are caught up in social and economic problems. And also because I think today, as far as relationships between Africans and Europeans go, there are aspects that are very positive, as well as very negative ones.

To my perception, what's happening in Europe and America belongs to me. One day someone asked me what I thought about Picasso and other European painters and I said, "In France, I took what belongs to me. Picasso came and took things from my home, I went to France and took things that are mine." For me the European tradition was a way of reunderstanding my own civilization's value, because Europe after the First World War was having a crisis of imagination, a crisis of development in an artistic sense, a cultural sense. And they turned to Africa. I also understand that they used my heritage to develop their own, so why can't I take theirs, whatever is technically useful to me, to express myself?

TM: When you say that you went to France and took what belongs to you, you don't mean that you were taking back purloined elements of African culture but that you were taking elements of European culture which belonged to you in exchange for them.

TD: I am not limited to African culture—that would be absurd; it would be ridiculous for any African today to speak of Africanity or Négritude. What you are is in everything, it's in your spirit. As an African you can never live exactly like a European—at least the people in my generation, I'm not talking about the ones who will come later. Sometimes I say to myself, sooner or later there is going to be an upheaval, a spiritual crisis in Africa. Those who come later, I don't know what's going to become of them.

TM: When you say that you and the members of your generation do not feel the tension between Europe and Africa, do you mean because you were born, or anyway raised, in the postcolonial era?

TD: Yes, exactly. For example, I was with [Moustapha] Dimé a little while ago. He speaks Wolof, and so do I. So we talked to each other in Wolof. When I go to see my relatives I speak in my own language, Bambara; when I am with a Frenchman I speak French.

TM: Wolof, Bambara, French, all these languages belong to you?

TD: Yes. There was a time when they said that we were going to choose a national language in Ivory Coast. Some asked if it should be Djula, but Ivoirians didn't want that because that language comes from Mali. Then there was talk about a Baule language, but tribal

Untitled, 1993
Mixed media on paper-
board
76.5 x 57 cm.
Collection of the artist

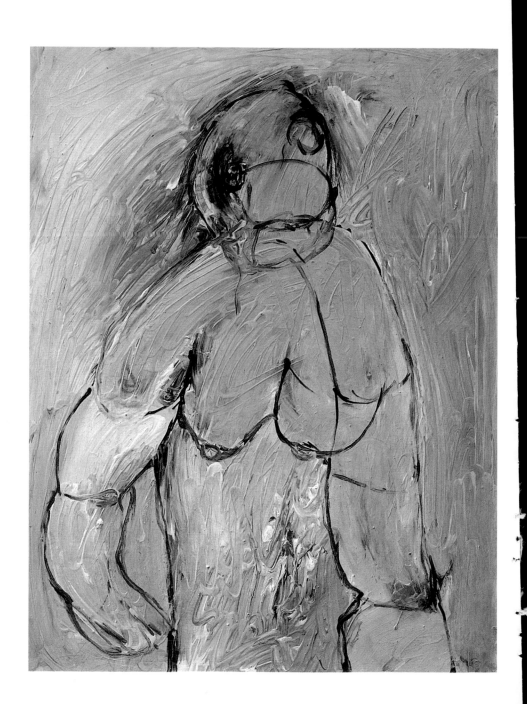

La Mère et ses enfants
(Mother and children),
1993
Mixed media on linen
130.5 x 97 cm.
Collection of the artist

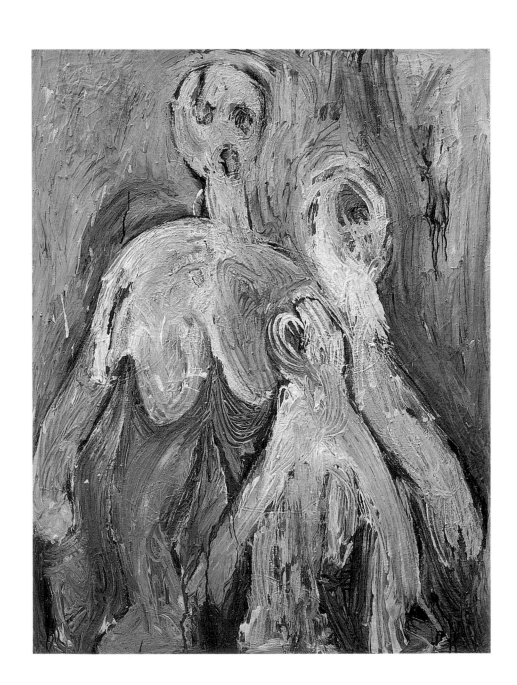

conflicts got in the way. Finally people adopted French as the national language, because it was not tied to any conflict.

TM: To say that French is "not tied to any conflict" is a very postcolonial statement indeed. Of course, as an imperial power, France for a long time had a sense of its own universality. Ironically, at the same time that it imposed this claimed universality on African nations, it understood it as a force that enabled it to welcome others. Picasso adopted France as his home for many years, and so did you.

TD: Picasso embodied universality in painting not through any exclusive purity of form, but through his diversity. What I especially like in him is that he didn't follow a single path. He showed that imagination and intelligence should permit you to diversify and do many different things without losing your identity. On the other side, when I was in France, I saw painters who painted the same way all their lives to keep an identity. I don't think that they are so interesting. You're not in the same mood all the time, the sun doesn't rise in the same way every day, you don't eat the same food at every meal.

TM: Who would be an artist who is limited in this way?

TD: I would think for example of Bernard Buffet, or for that matter of Dubuffet. Always the same. Maybe it's conditioned by galleries and all of that, but a painting shouldn't be conditioned by such things. Take Cézanne, for example—he developed and changed; Matisse also changed in his painting.

TM: Your own work has displayed a dynamic of change.

TD: Yes, a lot. I'm not satisfied to stay in one style or in one material. I've had periods that were very mystical, and also other kinds of periods. I've done oil painting, watercolor, ink drawing, collage.

TM: What other artists do you feel have influenced your work?

TD: Directly or indirectly, Delacroix, Matisse, Van Gogh, Picasso.

TM: Understandably a primarily French tradition.

TD: But also James Ensor, I love his paintings. And Egon Schiele.

TM: There is in their work, and in German expressionism in general, a use of the figure to express human agony in the real world, which I see also in your work here in Venice.

TD: Yes, that is what interests me in them. But Americans are important to me too. Pollock I like a lot; I first ran into his work in 1978. Also Stuart Davis, Sam Francis. I haven't seen actual works by Francis, but I've seen a reproduction, a big poster. I like his work a lot. An artist whom I admire and only encountered two years ago is de Kooning.

TM: If I could ask you a name or two, just to measure the overlap of our awarenesses from one direction: are you aware of the work of Robert Ryman?

TD: No.

TM: How about Frank Stella?

TD: No. Sometimes people have compared my work with Turner. I like Turner a lot.

TM: And Joseph Beuys?

TD: No.

TM: Is conceptual art a part of your awareness?

TD: No. I've heard people talk about it, but I'm not very theoretical.

TM: Your recent work, exhibited here in Venice, seems to me brilliantly delicate in its deployment of both the French and the American traditions, and with something else besides that is unique to it. According to the wall plaque, these frayed and tormented images embody a kind of lament for the decline in the quality of life in your homeland.

TD: Yes. As I said, my childhood passed in happiness. But today the country's really suffering, it's terrible. You see people who can't buy any medicine, people who are old, with two or three children, coming to beg for a few cents to buy something to eat. It's really terrible, the condition that people are in. It's from the neglectfulness of the people who are in power.

TM: Does this work represent a new departure, a new development, in your oeuvre?

TD: Yes. I can express things that have been bottled up in me for years. I would have done this long ago but I couldn't, I didn't have the technique. It was chance that allowed me to do it. It came from other things that I've done, that have led to this. For three months I plunged myself into it, I wouldn't say to the point of destroying myself, but to do something really interior. My wife and children went on vacation, and while they were away all of this came out, and when they returned my wife said, "No, that's not possible, you didn't do this stuff." I said to her, "What I've done here is better than anything I've done before."

TM: It is very powerful work. I admire it.

TD: It's my responsibility, it's everything I've not been able to show. It seems pretentious to say it, but it's a humanitarian side that I have in me.

TM: Do you feel that your work addresses Ivoirian human suffering, or human suffering as universal?

TD: Universal. I was very moved also by what was happening in Bosnia. Because I didn't realize that civilized countries in Europe could do such terrible things.

TM: Do you see art making a practical contribution to solving people's problems?

TD: Yes, but people can refuse the contribution. For example, when I did this work, I never showed it in Ivory Coast. I kept it in my house, I hid it. It was only when Susan [Vogel] came to the house to see it that I showed it. I showed it to only one person before, from the French Cultural Service. When he first saw it he was shocked and he left and didn't come back for three months.

TM: Is that why you didn't show it again?

TD: I couldn't show it in Ivory Coast because there *is* no place to show it. Or rather there is one gallery. But only one. I've never showed them this work because I have fears; there is more violence at home than here. I didn't want to show people. And anyway I'm not finished.

TM: Do you think it might be received as negative in some way?

TD: It may be badly received in Ivory Coast, because it makes people think about politics. I would have to explain. Imagine if the minister came to see the paintings and I explained that they were about misery. What would the minister say? I would be saying that the state is causing the misery of the people. In Ivory Coast I think I'm the only one who's doing this kind of painting. Because all I'm seeing is geometric compositions.

TM: Abstraction? Along Western lines?

TD: No, they do African symbols. I tell you right away, all the paintings that I have done

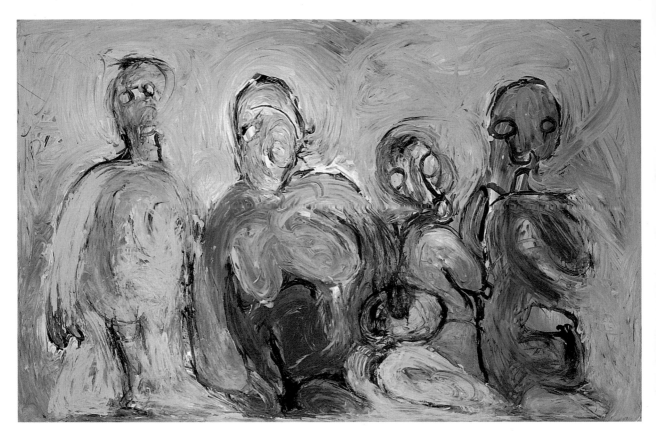

Soucis quotidiens
(Daily cares), 1993
Mixed media on linen
110 x 171 cm.
Collection of the artist

are completely different from what Ivoirians do. I hope that people in Africa get away from just doing geometric compositions. People imagine that if you do two or three African geometric signs, that will be enough. I don't like it at all. There is one thing that you have to take into consideration in painting, and that's the role of honesty in the work. Because you can do an African painting for Europeans to attract people's attention—that can be very easy. Or you can go beyond that and be in trouble. I'm very marginalized.

There are surrealist elements in things I've done in the past; surrealist painters interest me very much because they have a link with Africa in the automatic writing that they do. When I start to work I take a certain gesture from writing and it goes off by itself. Like André Masson, I like his work a lot. When we were in school we wrote with pens. When you scratch with a pen you make a certain noise, and when you write the sounds aren't always the same, according to slight changes in the gesture. That's very interesting and important. When I make a first mark in this way, if it is surrealistic, it has a connection with the mystical. It's like a spiritual voyage.

TM: Is the rest of the Ivoirian art scene also based in part on the French tradition?

TD: Yes.

TM: Just to measure my own ignorance, or the overlap of our awareness in the other direction, could you tell me something about it?

TD: In Ivory Coast some painters have formed what they call the "Vohu Vohu" group, meaning that they take all kinds of rejected and miscellaneous things and make a work of art out of them. Not sculptures—two-dimensional works. Sometimes they do collages with reliefs of cowries, sand, pebbles, and things like that.

TM: It sounds as if perhaps that aspect of the Ivoirian art scene is more directly African based than your own work.

TD: I can't say that. Art works depend on the vision of the individuals and their own research.

TM: To rephrase it: it could seem from what little I've heard that their works are less deeply resonant of European painting than your own—or that they are resonant of a strain of European painting that itself refers to African and other non-European traditions.

TD: I can't say that. But it is true that we don't have the same approach; we're very different in both concept and training. Though I get along with them and I respect what they do, we have nothing in common. In Ivory Coast, you see, there isn't much of a community of artists. Artists don't sit down together and talk about techniques or issues or anything.

TM: Yet it seems that the Vohu Vohu have formed a community of sorts.

TD: Yes, that's true. But there is resentment of it. Two years ago there was a big conflict between the Vohu Vohu and some other artists. It started during a lecture: an artist criticized the Vohu Vohu group, so they had to reply. He said that the Vohu Vohu didn't know how to draw, that they didn't in fact draw at all. There was also an argument about art for art's sake. To me these seemed somewhat empty intellectual discussions. I didn't follow that controversy closely, but it was all over television and in the newspapers. For three weeks it went on and on.

TM: It seems remarkable to me that television and newspapers would carry an artistic

debate, especially for so long. We rarely have art news in our papers, unless it's some politician attacking the arts, or some painting being sold for a record price.

TD: But when all this was going on, this discussion, I was not interested. I simply wanted to work. I say you're an artist, go do your work; go paint, that's all.

TM: So you as an artist seem to feel, in an immediate social sense, that you're working alone and in isolation, though in a broader sense you feel a spiritual affinity with tradition that you are nurturing.

TD: Yes, obviously.

TM: I wonder if in addition you might see art as an activity of transnational significance. Might you say that there is a globally shared project that artists in all parts of the world are involved in without knowing each other? That they are collaborating without even knowing each other?

TD: I think that would be wonderful.

TM: What is your artistic community?

TD: I have never confronted this question.

TM: How has your experience of Venice been?

TD: As I walk along here, I try to imagine what Leonardo would have felt like as he walked these streets, what he might have worn, what might have caught his eye. As the light goes down and I gaze over the lagoon at Venice, I try to see it as Turner would have seen it. I try to feel it as Leonardo would have felt it. What a wonderful privilege to be in the same city where Leonardo lived. I keep looking at present-day Italians and try to compare them with the Italians of the past and wonder why they did such great things in the past. When I look around, not only are the architectural monuments extraordinary, but the paintings as well. I don't see any link between the relics of the past and what I see today. I keep wondering, Are these the same people? Is it maybe because they created so much at that time that they don't now, that their imagination was more fertile at that time? Why do I think that God gave them more in the past than he's giving them now? I guess you can't give everything to one nation, you have to spread it around.

TM: That's the attitude that we call Orientalism when we do it to other cultures—to think that their past period was more valuable than their present one. It's an attitude that's characteristic of colonizing cultures looking at colonized ones. How interesting, and how significant of the postcolonial reversal, that now you're doing it to us, anyway to the Italians. I wonder if you're familiar with the writings of Cheik Anta Diop.

TD: People talked a lot about him when I was much younger, but not so much recently. Now there are others who are more important, like Ousmane Sembene. For example, *God's Ends of Sticks*—when I saw that film I saw my childhood.

TM: Do you know Sembene's *Mandabi*, in English called *The Money Order*? It shows a Moslem household?

TD: Yes, that's home.

TM: When you were describing your childhood I thought of this Sembene film constantly.

TD: That's the period, and that's what it was like. I'm not nostalgic for the past. Because it's dangerous to be nostalgic for the past, you have to keep moving forward or you kill yourself. I had a happy childhood, it was magnificent, it was good. But today Western civilization has spread so much across us—especially in Ivory Coast, especially in Ivory Coast.

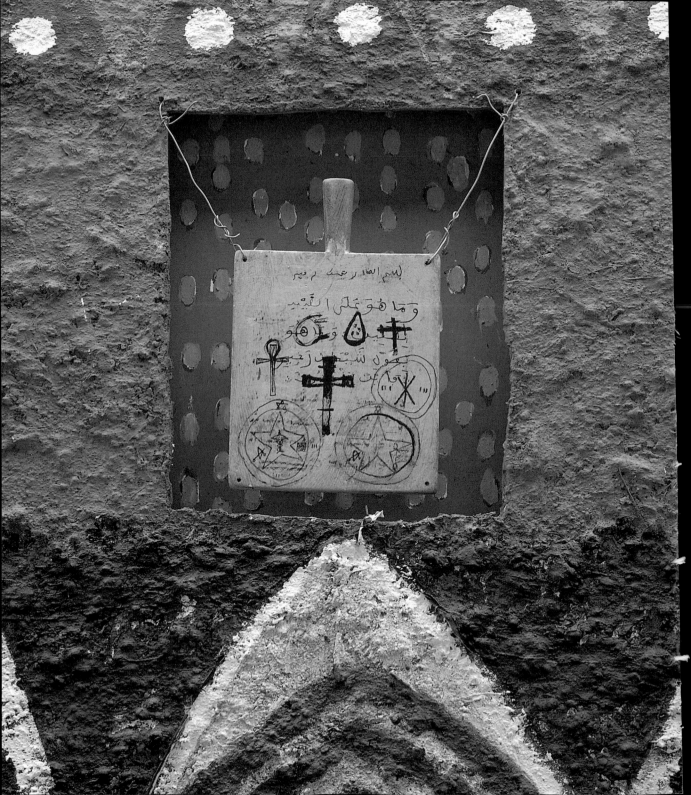

An Interview with Ouattara

Thomas McEvilley
New York City, 21 July 1993

Thomas McEvilley: When and where were you born?

Ouattara: I was born in 1957 in Abidjan, Ivory Coast.

TM: In 1957, was Abidjan a big urban center, like today?

O: Yes, it was already an urban center, and already very multicultural.

TM: Would you tell me a little about your family?

O: I prefer to talk about my work.

TM: I'm interested both in your work and in the background of your work; I hope you don't mind if I try to find out what kind of cultural and social conditions it comes from.

O: That's all coincidence and accident. I could have been born in Russia, in Canada, or in Africa. But, if you must know—it's a large family, with many sisters and brothers.

TM: How many?

O: That has nothing to do with my work, and I'd rather not say.

TM: What kind of school did you go to as a child?

O: A European school, the students about half African and half European.

TM: A French school?

O: Yes.

TM: And what language was spoken in your home?

O: Bambara. And of course French too, but if you speak Bambara, all Ivoirians speak it. No problem. Even though Ivory Coast has eighteen different dialects. Bambara is the language of commerce. If you go to the market, if you go to Mali or Senegal, the people speak Bambara. But I also speak Senufo because my family comes from a village in that region in the northern part of Ivory Coast. Senufo are in Mali, Burkina Faso, and Ivory Coast.

TM: What was your father's profession?

O: European and African medicine. In traditional medicine he was a healer but in Western medicine he was a surgeon. He would try Western medicine first, and if he failed to cure through Western medicine he would try traditional African medicine. There were certain diseases that he couldn't treat with Western medicine, and the other way around also.

TM: The traditional healing practices involve ritual, don't they, and sometimes animal sacrifice?

O: Sometimes. Chickens.

TM: What religion did your family practice?

O: We tried everything, we believed in everything. That's voodoo. If you try Catholicism or

Opposite, detail: *Nok Culture*, 1993
Acrylic and mixed media on wood
295.91 x 202.56 cm.
Collection of the artist

Protestantism by itself in Africa it causes problems. So you mix them all with African traditional religion.

TM: Catholicism, Protestantism, Judaism, Islam—mix them all together with traditional African religion and you get voodoo?

O: Yes. My father was a shaman whose practice was based on a religion with the widest possible scope.

TM: You had the standard French education until what year of your life?

O: I started at age six or seven and remained until I finished, until age eighteen, before the university. But beside the *lycée* I had a spiritual education, meaning initiation school. My first education was not in the French school but in the initiation school, the spirit school, the African school. You go to the jungle and do something like a spirit. It began there.

TM: At what age was this initiation?

O: Seven. Before seven, if your family is strong in spirituality, there are family ceremonies; then after seven you go to spirit school yourself.

TM: And the initiation involves spending some days and nights in the jungle?

O: Yes. The spiritual school permits you to understand the world. You are allowed a vision that is cosmic rather than a nationalistic or village-oriented one. Therefore you are the sun, the rain, the Mexican, the American, the Japanese, etc. It is the cosmic view of the world.

TM: By whom was your initiation carried out?

O: The old shaman of the village.

TM: Did the girls in your family also undergo initiation?

O: Some, not all. But all the young men do.

TM: Did the initiation practice involve the use of pictures or ritual objects?

O: Yes, cabalistic objects.

TM: Are these things provided by the shaman who conducts the initiation?

O: Yes.

TM: They are not made by you in the process of initiation?

O: Some are already made and are reused over and over, some they make for you when you begin, and you make some as well.

TM: Can you describe some of these objects?

O: They are symbols that I still use in my work, for example the bullroarer, a sacred musical instrument. At the beginning of the ceremony it is used to call the spirits to pray. It's a magical instrument.

TM: How does it figure in your work?

O: I illustrate it.

TM: You do not sculpturally incorporate it?

O: No.

TM: Do other elements of your work, such as the window in *Masada*, derive ultimately from initiatory objects?

O: Yes, there are some images that come from the initiation ceremony. You'll see symbols and writings that I learned from the ceremonies.

TM: Did you see things like these images during the rest of your life in Ivory Coast, or are they seen only in the ceremony itself?

O: They are seen widely in the culture.

TM: When you incorporate such images into your work, do you remember them from your own initiation, or are they images of the type that one sees in the culture roundabout?

O: There are images that come from the initiation ceremony itself, and symbols I have found elsewhere that I mix with them. Certain images from the ceremony are suitable, but some are forbidden, you are not allowed to use them, so I respect that tradition.

TM: When you were seven, in Abidjan, was there Western popular imagery around at the same time?

O: Yes—advertising, cars, people's clothes.

TM: What type of art education was taught in the *lycée*?

O: Very little. Only in the context of the story of the history of the West.

TM: Did the history of the West interest you in school?

O: Yes, I was interested in the West.

TM: What Western authors were you attracted to?

O: When I was in school, not much. Afterwards, when I pursued my self-education in France, I was interested in Kafka, and in Henri Michaux.

TM: What types of drawings or art objects did you make as a child?

O: Very bizarre, very strange drawings, very mysterious, close to surrealism.

TM: How were they related to surrealism—in the way they mixed African and Western motifs?

O: Yes, the mixture that came from the combination of Western and African education. I only discovered this later, when I started finding books on surrealism.

TM: What about comic books and cartoons? As a child did you draw from those?

O: No, we didn't have them much in Africa. Just Tarzan, things like that.

TM: Was your artmaking as a child immediately influenced by your initiation?

O: Yes.

TM: Did you practice art inside or outside school?

O: At home, always. Drawing with pen and paper, gouache and watercolor, house paints.

TM: Were you very early on recognized as talented in this activity?

O: That was recognized at the age of seven, at the initiation ceremony itself. Based on what I was creating as part of the initiation ceremony. After that I would do whatever I

73

wanted. I didn't wait for them to teach me in school. I did it at home.

TM: Were they magical objects that you made in connection with the initiation ceremony?

O: Yes.

TM: When you made artworks later, did they still have this magical nature?

O: Yes, even today, my work still has that power, magic. I always start my work with a ceremony, even today.

TM: Can you describe that ceremony?

O: It's like a prayer, a trance. It's difficult to describe, like painting.

TM: Do you work in this state? Or is it a transition state?

O: There are two stages. First you get into the trance, which takes you someplace, then you come down and start working. When you start working, you are like everyone else, like other artists. But you still lose control, and it is not you who paints. Other artists will tell you too that it just takes over.

TM: Could you discuss the magical and spiritual intentions behind your works today?

O: We live in a totally technological world today, a world where if you push a button everybody can blow up. Before Hiroshima, they thought man was immortal, but after Hiroshima the world is mortal. I think that spirituality must permit people like us, who are in the grip of technology, to better appropriate and take over the technology.

TM: So a spiritual condition that your work might produce in the viewer might also contribute to a more humane use of technology?

O: Yes, the viewer must better understand technology to better appropriate and adapt technology, to give it a more humane quality. It's important not to lose control of technology.

TM: So the experience that the viewer is expected to have of your work is a kind of initiatory experience? The work contains a kind of spiritual force that can enter the viewer?

O: Yes.

TM: So in a sense you are doing the same thing that your father did.

O: Yes, and the elders in general, not just my father. Artists in general speak of progress, but in creation there is no progress. It's a circle, you always come back to the same thing. You think there is a break but there isn't. You always do the same research, just four or five subjects, god, love, life, etc. So it's always the same research, it's a cycle.

TM: You would have graduated from the *lycée* in 1965, I believe.

O: Before finishing the *lycée* I got out, I ran away. Took off. My mind wasn't concentrating on the *lycée*. If I'd stayed I was supposed to become a doctor, and I didn't want to become a doctor. I got out of the *lycée* at age sixteen to have more time to work on my paintings.

TM: Your father didn't mind that you left the *lycée*?

O: A bit. But he let me stay and do my artwork at home. My mother too, she was very good in spiritualism.

TM: At this time your artwork was primarily painting? Or did it involve the sculptural elements that your work now involves?

O: I was already attaching things to the canvas, mostly pieces of wood. There's not that much difference between painting and sculpture. If you are born in Africa, sculpture and painting are the same.

Masada, 1993
Acrylic and mixed media on wood
295.91 x 256.54 cm.
Collection of Cavaliero Fine Arts, New York

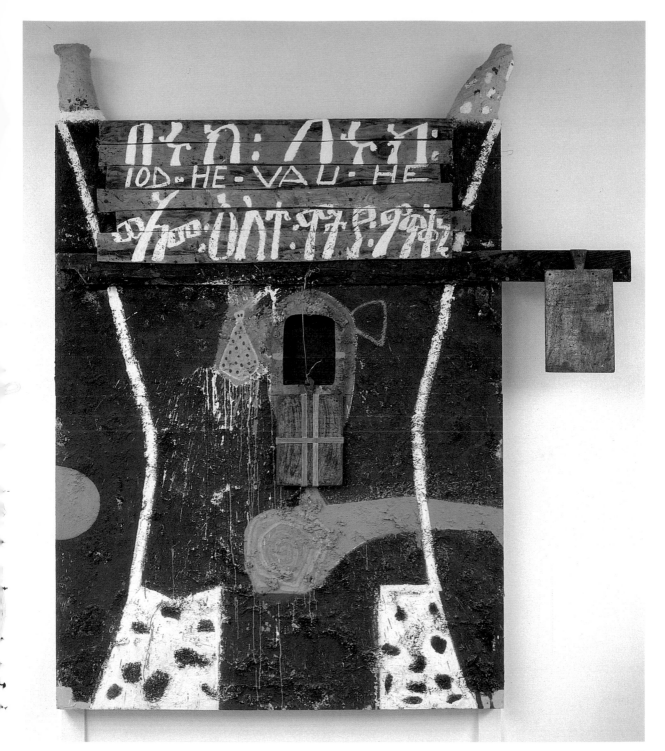

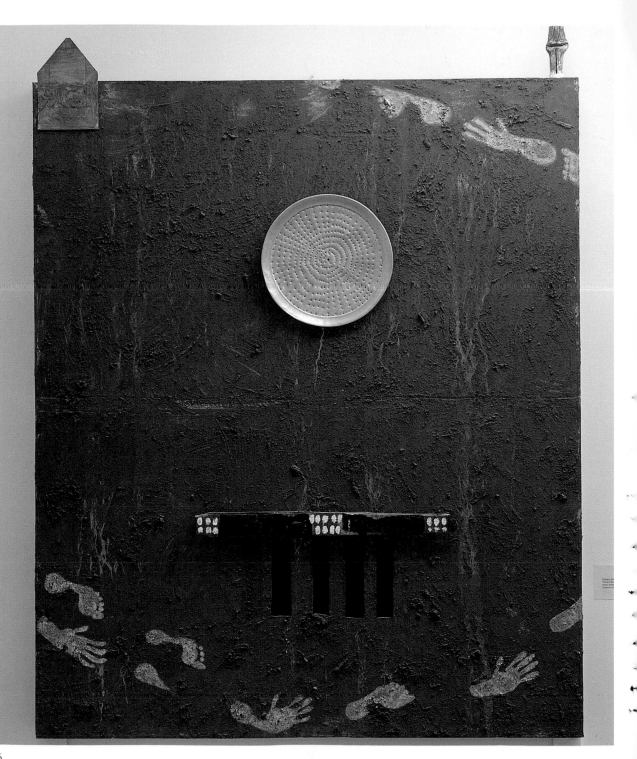

TM: In Africa, many of the power or ritual objects were assemblages.

O: Yes. When I came to the West and I saw some people's work I said, I have seen this type of work before. When I encountered Duchamp, for example; I like Duchamp.

TM: Or early assemblages by Rauschenberg?

O: Yes. But that was later, after I came to America. Before coming to the U.S. I lived in Paris, where I went when I was nineteen. I went to Paris because of history, because it is where Picasso and his group all lived. I lived there for eleven years.

TM: Were you aware of Picasso before you went to Paris?

O: Yes, at the age of nineteen I knew about Picasso. I saw his work in books in libraries in Abidjan. The French Cultural Center had a large library. There was also an English Cultural Center. And the Goethe Institute.

TM: The cultural centers also gave exhibitions, did they not?

O: Yes, even today they do. But I didn't go to the exhibitions because the first time I saw Western art at the galleries I didn't like the work. Therefore I didn't go to the institutions.

TM: Was there a museum in Abidjan?

O: No, not at the time. There were some galleries but they showed commercial things that I didn't like. Western things to be sold to Africans. Landscapes, School of Paris style.

TM: But in a kitsch sense?

O: Yes. Before going to Europe I saw Western art only in books, then when I went to Europe I went to the museums. When I studied the books I felt an affinity. I wanted to see the actual paintings.

TM: Did this sense of affinity arise in part because of the African influence on Picasso?

O: No, you could also talk about Matisse, it's not specifically Picasso.

TM: So it's not the African influence?

O: Well, in part it was. Picasso, Miro, Brancusi—a lot of people who were still living—their work was like a mirror to me. They were people different from me but still inspired by African art, by "first art." For me it was a mirror; I saw myself through them.

TM: So you saw yourself reflected back through them, and also you saw something that was not yourself, that came from the European element.

O: Yes, it was not just African influence. When I saw the black paintings of Goya, that was like a mirror also.

TM: And when you arrived in Paris, what was your situation?

O: It was very hard. I lived as if in a barracoon, where they kept the slaves. From 1977 until 1986, it was very horrible. I didn't want to show my work at the time. I had never showed my work in Abidjan and for nine years in Paris I didn't want to show it, because I needed to make a synthesis of everything I had learned in Africa and everything that I was learning in the West; I had to assimilate it all. Then in 1986, a French art critic came to see my work and was interested in it. She is Jewish, and she was interested in the cabalistic elements of the paintings. She showed my work in a gallery. Then other galleries also started to inquire.

TM: Did the elements that she recognized as cabalistic go back to traditional African roots, such as the initiatory symbols?

O: Yes. And the exhibition was successful. Everything sold, because I got reviews in the

newspapers. So I had some money after that show, and I got a bigger studio and really started working. Then I heard of a dealer in Germany, Paul Mainz, who might be interested in this type of work. I read an interview with Mainz and I liked his ideas and what he was doing. I decided to do some work and then go to see Mainz in Cologne. But something happened. At the end of 1987 and the beginning of 1988 there was an exhibition of Jean-Michel Basquiat in Paris. I went to the exhibition in January of '88 and I met Jean-Michel. He put his hand on my shoulder and introduced himself. I didn't believe who it was. Then he asked if I was an artist, and asked to see my work. And I told that person, "If you really are Jean-Michel, it's your exhibition, you can't leave, you have to stay here." But he asked to come to my studio. So he came and saw the work, he liked the paintings and bought the whole series. I said, But I made these paintings to take to Germany to show Paul Mainz. He said, I like your work and I want to buy them—make more for Germany!

Then Jean-Michel came back to New York and showed the work to Vrej Baghoomian, who looked at the work and was interested. Jean-Michel asked me to come to New York and introduced me to Baghoomian. He put me in a group show in 1988, and after that, in 1989, he gave me a one-man show. After the one-man show I stayed in New York.

TM: Do you like it in New York?

O: Yes, it is like Abidjan. If you go from Africa to Europe it is very different, but when you come here it is more the same. Abidjan is a new city, New York is a new city.

TM: And also very multicultural.

O: Yes.

TM: How does your work relate to the contemporary art scene in New York?

O: I don't know. They come, they talk, they discuss, there's no problem.

TM: Does your work participate in the contemporary art flow in New York, in the sense that it both gives and takes influences? I mean, do you think you're making the same work that you would have made if you had not come to New York, or has your work been influenced by New York?

O: No, I don't believe I would have done the same work in Paris. New York is a much more active city.

TM: Are there artists currently working in New York to whom you feel your work relates?

O: Not necessarily people in New York today. It's closer to Jackson Pollock.

TM: The work you made when you were in Paris has prominent Egyptian elements. Where did they derive from?

O: Africa.

TM: In Abidjan one sees Egyptian imagery in African artwork?

O: Yes, in traditional African art.

TM: Would one attribute this in part to the influence of the writer Cheik Anta Diop?

O: Yes, but it was there before Diop. Cheik Anta talked about this, but many people talked about it before him. Cheik Anta was just the first to make a book about it. What he did was systematize the whole thing in relation to the Greek philosophers and so on.

TM: Do you foresee motifs from contemporary American culture entering into your work

Opposite, detail: *Masada*, 1993
Acrylic and mixed media on wood
295.91 x 256.54 cm.
Collection of Cavaliero Fine Arts, New York

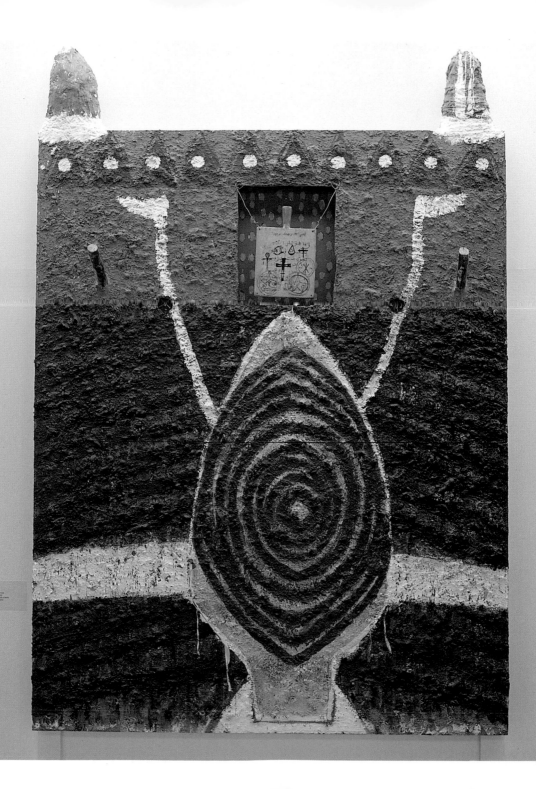

too?

O: Yes, at this time I am working on some elements of this sort. But not only typically American things. My work has two feet, it involves technology in relationship to spirituality, the cosmic work.

TM: Do you foresee a kind of synthesis of technology and spirituality?

O: Yes.

TM: Do you see technology as representing the West and spirituality as representing Africa?

O: No, there is also a type of spirituality in the West and a type of technology in Africa. Though in the West, technology is much further along.

TM: Are you interested in contributing to a synthesis of Africa and the West?

O: Yes. When I came to America, to modern society, I saw man in relationship to the cosmos, everything that touches man.

TM: Do you see art as one force that will contribute to this synthesis?

O: Yes, when you talk about freedom, art is the liberator. People like Beuys are interested in liberation through art. I like Beuys. He touched certain elements that I'm interested in in art. But today you could go further than he did, because you could create more spirituality on a larger scale that could give you a bigger breadth, total liberation.

TM: Am I right in thinking that you have done some performance works?

O: Not really. But I've done private rituals in relation to cosmic visual art. Beuys did something like that, for example when he explained painting to a dead hare. But I think that the

dead hare should explain painting to Beuys. You must respect the dead; it's not for Beuys to explain painting to the dead, the dead knows painting already, he knows or sees everything. If Beuys were alive, we would have a lot to say to each other. I have a lot of admiration for him.

TM: I don't have any more questions. Do you have anything more you'd like to say?

O: I'd like to say this: my vision is not based only on a country or a continent, it's beyond geography or what you see on a map, it's much more than that. I hope people will understand that it's more than geography. Even though I localize it to make it understood better, it's wider than that. It refers to the cosmos.

Nok Culture, 1993
Acrylic and mixed media
on wood
295.91 x 202.56 cm.
Collection of the artist

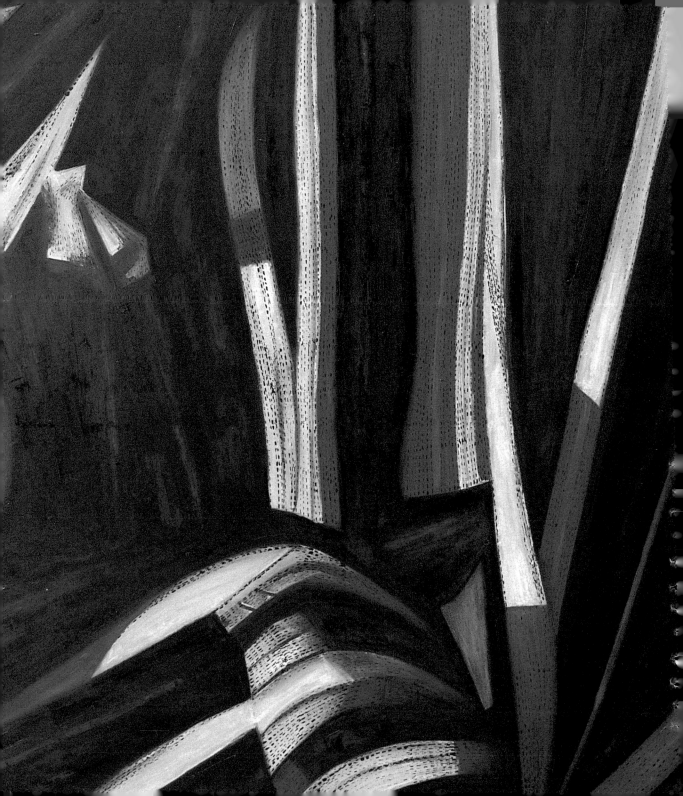

An Interview with Gerard Santoni

Thomas McEvilley
Venice, 12 June 1993

Thomas McEvilley: When and where were you born?

Gerard Santoni: I was born in 1943, in the southwestern part of Ivory Coast in the little town of Divo, 200 kilometers from Abidjan. My father was French, my mother Ivoirian. By the time I was born my father had gone back to France—this was during World War II.

TM: Why had your father been there in the first place?

GS: He was working on a cocoa plantation, sort of the works supervisor.

TM: A colonialist?

GS: No, he was there for private business. Divo had a lot of foreigners at the time because it was the center of a large lumber industry.

After he left, I was raised by my mother like a regular Ivoirian until I did my elementary education. Then I went to a special school in Bangerville, which is near Abidjan. It was a school founded by the French for children of mixed blood, children who were part French. It was called an orphanage, but it was really for children that the French had left behind. It was considered a big privilege to go to this school. The orphanage was in the old French governor's mansion, it was a very splendid place.

TM: Designating you as orphans would seem to involve a denial of your African heritage, or a denial of the problem of racially mixed lineages.

GS: Perhaps so. When I lived there, I saw my mother only during vacations.

TM: What type of education did you receive there?

GS: It was like a French education. They didn't allow us to speak anything but French.

TM: Were you taught French literature, what a French youngster would read in school?

GS: No, there were special books for schools in the colonies. There was a whole series of books called "Mamadou and Bineta," which taught kids how to speak French. Mamadou is a very common name throughout Africa for a boy.

TM: Did you see Tintin comics?

GS: No, but we sang French songs, like *"Frère Jacques."*

TM: Did you eat African or French food?

GS: Local foods, things like potato. On Thursday, if you hadn't been bad, you were allowed to have *pain chocolat*.

TM: As the kids got older, of course, they must have read beyond "Mamadou."

Opposite, detail:
Untitled No. 5, 1993
Oil on canvas
195 x 130 cm.
Collection of the artist

GS: Yes, we read French classical literature—Baudelaire, Pascal, Racine. The director of the school was very anxious to teach us to like classical music. So we heard that every day.

TM: Did you ever feel that the education was alien or artificial or imposed?

GS: There was some feeling like that, but it was offset by the fact that we were considered privileged to be there.

TM: And now how do you feel about that education—still privileged, still happy about it?

GS: Yes. It wasn't a particularly happy experience, but I think it was good for me and I learned a lot of things. It was a difficult life, sort of like the military, with strict discipline. Even though at the time we weren't very happy, we thought we were lucky in a way, because we saw that we were privileged compared to other students.

TM: What was the art education like in this special school?

GS: On Thursdays, which was the day that all French children were given the afternoon off, in the afternoon we were encouraged to paint or do sculpture. We were given materials to do that. We were allowed to make masks, or any kind of thing we wanted. We made masks like carnival masks, not traditional masks, glazing hot-iron motifs on gourds or calabashes. We also did African scenes, African landscapes, traditional houses, villages, things like that.

TM: And after primary school?

GS: My secondary education was no longer in the orphanage. I went to what was called the Modern High School in the same town. I did the secondary cycle and got the bacc. [baccalaureate]. There was what they called the Classic Cycle or the Modern Cycle; I went into the Modern Cycle. You took an exam and then they told you which they thought you'd do better in. But both were general education; they had different names but they were much the same. There were even French students in the school. It was basically a French high school, all of the children of French administrators went there.

TM: And here you continued to do artwork?

GS: Yes. It was encouraging to me, because when I finished a piece, people would say I was good at it.

TM: Was it painting or drawing?

GS: I was interested in painting but never did any before leaving for France. I had a drawing class in secondary school but I wasn't the best in the class.

TM: Did works of traditional African art occupy a place in your attention at this time?

GS: I thought of them as religious objects, not art objects.

TM: In school, did you come in contact with works of French or European art?

GS: I don't remember even photographs of works of art.

TM: And yet you developed this ambition to become an artist, to go to France, to go to the École des Beaux-Arts. Was that ambition based on a purely intuitive feeling?

GS: People told me that I was good at drawing. And I liked to draw.

TM: Was your early work, before going to France, made with pencil or with ink? Charcoal, crayon, pastel? Was it figurative?

GS: Crayons, often landscapes.

TM: What was the model for these landscapes? Were they like Cézanne or like traditional African landscape carvings?

GS: Imaginary landscapes. I had never seen a French landscape.

TM: Were they influenced by African bas-relief wood carvings?

GS: No.

TM: How do you make landscape drawings if you haven't seen landscape drawings?

GS: They were imaginary landscapes, but they were of things that I'd seen, like people rowing canoes or traditional houses or things like that. We worked out the perspective and other things like that by ourselves; nobody taught us, even though there was a class—that Thursday afternoon—where we did this stuff. Instead of a class they called it a directed activity. Nobody ever suggested that we go outside to draw; it was done in a studio.

When I graduated I decided to go to the École des Beaux-Arts in France. I had an Ivoirian government scholarship.

TM: You must have had a distinguished high school career to get that scholarship.

GS: No, it was much easier to get a scholarship when you got out of high school then, because the number of educated Ivoirians was very small. Ivory Coast at the time of independence did not have many educated people, even as the colonies went.

TM: How old were you when you went to France?

GS: It was in 1964, so I was 21. I started in the École des Beaux-Arts in Paris, but decided after a year to switch to Nice. Things were just too loose in Paris; they were already in the early '60s starting to have the troubles that erupted in 1968. The men in the French ministry of education suggested that I switch to Nice.

TM: Were you the only Ivoirian there?

GS: No, I was the second Ivoirian to study in Nice. After I finished the degree, I had a diploma in decoration. That was in 1968. Then the Ivoirian government wanted to send me to do a training session at French television for four months, because they were just about to start their own television station in Abidjan and they wanted to train somebody to do set design. So they sent me on this training program. After three years of working at set design, I was the main set designer at the Ivoirian television station for three more years, from about 1971 to '73. But they had such poor facilities, since they had very little money and few materials, that I decided I was wasting my time. Also teachers are much more respected, and are paid more, in Ivory Coast. So I became a teacher. Since 1973 I have been teaching at the National Institute of Fine Arts.

TM: I believe you have been to the United States, is that right?

GS: Yes. In the '70s the United States Information Agency was bringing young Africans to the U.S. One year they brought a group of visual artists. I was proposed by the ministry of culture in Ivory Coast. It was 1978 or 1979, I'm not sure which. Ten or twelve artists came from all over the continent. There was actually a small show in New York, but mostly we traveled around, visited schools of art, got a chance to meet artists and talk to them. Everyone went to New York and Washington, but some went to San Francisco, some didn't. I went to Minneapolis.

TM: After education both in Africa and Europe, do you regard your work as primarily African or primarily European, or as having both European and African connections?

GS: The point of departure for these paintings is the tradition of Baule weavings, which are

Untitled No. 4, 1993
Oil on canvas
100 x 81 cm.
Collection of the artist

Untitled No. 1, 1993
Oil on canvas
114 x 146 cm.
Collection of the artist

tapestries made of narrow bands sewn together. The dominant color is indigo blue, and there is a little red stripe at the bottom of the cloth. White is important in them too. I break down the traditional weavings, "decompose" them, and find something personal in their decomposition.

TM: I wonder if this work might still retain an imprint of the landscape work of your early period in the orphanage.

GS: In what way?

TM: The way the surface is articulated horizontally, the sense of accumulation of layers like geological strata.

GS: Yes, when I "decompose" the cloths the results often remind me of marine seascapes or coastal views. They can also remind me of other landscapes, like the Saharan landscapes where there is no water, only sand and rocks.

TM: So , the level of origin the works relate to the Baule tapestries, but on another level they resemble landscapes and seascapes. And it seems to me they also resemble some Modernist abstraction or quasi-abstraction, such as the work of Nicolas De Stael.

GS: I am comfortable with that idea because I don't think it makes sense to have a specifically African painting or specifically Ivoirian or Senegalese painting. I'm glad to see myself as part of a world tradition.

TM: Do you intentionally and self-consciously attempt to locate your work at an intersection where it can be appropriately seen as either African or European at the same time?

GS: No, not consciously. I think that is implicit in my training, because I was trained in the École des Beaux-Arts; all my training in painting technique is French.

TM: Do you work only in oil paints?

GS: I tried acrylics but find the colors less subtle.

TM: Acrylic is more American, isn't it, while oil is of Europe?

GS: I simply found the colors in acrylic less subtle.

TM: Perhaps that's part of its being American.

GS: I simply like working in oil.

TM: For how long have the Baule fabrics served as a basis or starting point for your work?

GS: I have worked with these materials and sources for at least ten years. Before that I worked on other things. My work from ten years and more ago looks very different.

TM: To me it seems significant, or at least intriguing, that the Baule fabrics are from your mother's heritage. Painting in this French medium and technique, on models and themes that are African, seems to combine the heritages of your father and your mother.

GS: I don't feel that I'm working on a specifically African fabric; I'm just using cloth. And I'm not trying to do any symbolism. You have to remember that these cloths have decorative elements in them that illustrate proverbs, but I seldom use them. Occasionally you may have noticed one with little green motifs in it; those motifs have names and refer to proverbs, but I don't use them very much. To me it's just the use of colors in themselves. The placement of the blue, white, and red is the crucial element.

TM: You don't feel it's meaningful to break down your work into different ethnic or cultural roots?

GS: Well, after all my mother is Baule, of course, and so the Baule fabric is from the region that I know. It's just natural to me to use it.

TM: But your father is French.

GS: He wasn't exactly French, he was Corsican. I am Ivoirian as you are American. I don't like this line of questioning.

TM: I see. Do you mean that I as an American am also of a mixed heritage, yet I would simply call myself an American?

GS: Of course.

TM: If you are not happy with this way of looking at it, by breaking it down into different influences or lineages, then what kind of account would you prefer? Would it be an account that stresses an individual sensibility rather than cultural inheritance?

GS: Yes, that's true of everybody. I use painting as an element to express myself, and I use European paint because I'm not about to start to make my own paint. Tamessir [Dia], who is not of mixed ancestry, is using oil paint on another subject. My personal feeling is that I could pick other subjects aside from sources of inspiration from my own region.

TM: So painting with oil paint on canvas cloth is simply a way to express oneself that is neutral of cultural assumptions.

GS: Yes. I would also like to say, I could be like some of the other artists from my area who take soil and mix it with glue, or use other local materials, but that doesn't interest me. I could also use traditional African indigo pigment in my painting, but I don't because it wouldn't be as durable.

TM: Would you be willing to name some artists whose work has been important to you?

GS: I don't absolutely like everything about any artist, but there are people who do things that I like. For example, I like Picasso's African period. And Klee, and Kandinsky. I saw the Matisse show [last year in New York City] and liked it very much. The light, the spontaneity, the cutouts.

TM: Do you see your own work as participating in a discussion with the works of other artists?

GS: What I do is entirely personal.

TM: I think to be an artist means to participate in a vast communication of humankind. And I think this means there must be people with whom the artist is communicating. But maybe I'm wrong to generalize about that.

GS: My works resemble my own feelings. It sometimes happens that I will see an artwork by another artist and I'll think, That is interesting, I would like to do something like that. But I don't do it. When I see Pollock, for example, I'm very taken by it. The spontaneity, the liberation of it attracts me, but I don't think of reproducing it. Pollock's the one who invented that, and who mastered the technique. I don't want to imitate it.

TM: Do you think your work communicates with African viewers?

GS: When people come to my house, they immediately recognize the subject matter. Both artists and ordinary people. I'm talking about Ivoirians who know what the cloth is.

TM: Do Ivoirians also respond to the aspect of irreducible personal sensibility in the work?

GS: People who aren't artists, they come into my house, they look at it, and they say,

Untitled No. 5, 1993
Oil on canvas
195 x 130 cm.
Collection of the artist

"That's beautiful." But they don't necessarily understand anything about it.

TM: If they did understand something about it, what would it be that they understood?

GS: They might understand that I have some personal problem or issue of feeling that I am expressing.

TM: What might such a personal problem or issue be?

GS: I have been influenced by the type of thing that Susan [Vogel] wrote about. It could be a personal sort of lack of equilibrium, it could be a personal issue, or something that has to do with the social or political situation.

TM: Your work does reflect the social environment?

GS: That's what Susan says. What I said to Susan was that I am trying to attain through painting a kind of calm or serenity. Susan sees something stronger. She has the right to say what she wants to.

TM: Do you agree with Susan that your work reflects social unrest?

GS: I agree that she has a right to see that in it.

TM: Do *you* think your work reflects social unrest?

GS: I feel that since the work is abstract people can see what they want to see in it. What I am looking for in my painting is a kind of calm and peace and serenity that's very personal. I am looking for an interior calm that I am trying to find in myself.

TM: Is this interior calm based on the grasping of a pure form? Is there, to you, any reality in that concept?

GS: I feel that what I am doing is withdrawing to a place where I am looking for calm and peace while I am painting.

TM: Formally, in terms of shape and structure, your work seems to emphasize horizontality, or a range from the diagonal to the horizontal.

GS: Yes, primarily they are horizontal and diagonal.

TM: And that involves the serenity idea?

GS: The horizontal, after all, is related to the idea of horizon.

TM: So there is landscape, the serenity of landscape?

GS: But I want a horizontal line that is dynamic. That is why I use the diagonal lines along with the horizontal, to make it more alive and dynamic.

TM: That's why I thought your work related to the work of de Stael. Do you agree that there might be a similarity?

GS: Yes, you are right.

TM: Insofar as your work is designed to go down in art history, to be recorded in art history, how do you see it contextualized in history as it will be written in the future? That's the first time you've laughed.

GS: I don't even think about that. I don't even think I am part of art history.

TM: Your work is just this crystalline expression of your selfhood, without any relation to anything else?

GS: I am concerned about showing what I do and communicating with other people. I want people to see it and be interested.

TM: So you agree that your work might speak to other sensibilities?

GS: Yes.

TM: What do you call that? What is that relationship, is it a kind of a love, a lovelike desire to be a part of humanity, and to participate in humanity?

GS: I am following my way, my path, and I don't know where this path is going to take me. I just do what I want to do, and I don't care if it looks like anybody else's work or not.

TM: Yet whom do you admire among other living artists?

GS: You've asked me that twice already. There is no artist whom I admire everything about. But I like Degas's ballet dancers, and I like Renoir. And Picasso's Blue Period pleased me immediately.

TM: They aren't living.

GS: Of course. You see, I spend a month every year in New York, but I am more likely at that time to go to shows of earlier artists. For instance a show that I went to see recently was the Matisse show. I also went to see the Fauve landscape show at the Met and liked it very much.

TM: Yes, that seems clearly relevant to your work. You must have appreciated reading about the famous Fauve show of 1907.

GS: I like the fact that there was a group of different artists who had a common vision of things.

TM: Yet—I know I've asked you this at least twice already—you feel no need to see your work in terms of the work of other artists alive and working today? For example, your references to stitched-together fabrics have something in common with a large group of works by Lucas Samaras, which you may not have seen.

GS: No. I haven't, and I don't care. I mean, I would be interested in seeing how somebody whose work maybe resembled my work in some way got started, what his procedure is. But it wouldn't make any difference to my own work. I wish I could explain how I work, how I see color.

TM: I admire your work, and I feel its reality. But to me there seems to be an imperative of contextualizing its reality within the feeling-tones of other contemporary artwork. I would like your work to be a part of the discourse of contemporary art.

GS: I feel that what I do could have come out of any country.

TM: Aside from the references to Baule fabrics, I guess you're right—but with some reservations; I mean, I think that in the wake of Western Modernism spread abroad by colonialism, it could have arisen anywhere. Otherwise, perhaps not. The products of different countries, as represented here for example, are often very different. Have you seen the German pavilion, where Hans Haacke had the marble floor from the Nazi period torn up and smashed?

GS: That's ephemeral art; no art object. The fact that there's no object there, that's not a part of my way of looking at art at all. I exhibited years ago in São Paulo, and it was the same thing there—the show was dominated by a desire to shock people. So I expected that here too.

TM: Do you think Haacke's piece arose simply from a desire to shock?

Untitled No. 2, 1993
Oil on canvas
97 x 130 cm.
Collection of the artist

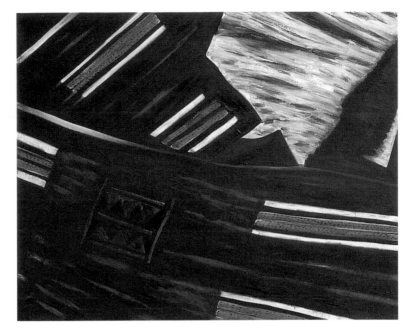

Untitled No. 3, 1993
Oil on canvas
130 x 97 cm.
Collection of the artist

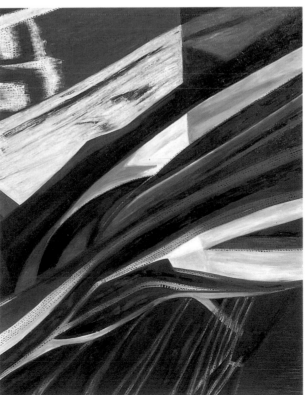

Museum, Berkeley; Dallas Museum of Art, Dallas; St. Louis Art Museum; Mint Museum of Art, Charlotte; Carnegie Museum of Art, Pittsburgh; Corcoran Gallery of Art, Washington, D.C.; Center for Fine Arts, Miami; Ludwig Forum, Aachen; Antoni Tapies Foundation, Barcelona; Espace Lyonnais d'Art Contemporain, Lyons; Tate Gallery, Liverpool

1992 "Other Drums: Visionary Works," Cavin-Morris Gallery, New York
 "Haessle, Ouattara, Ray Smith," Cavaliero Fine Arts, New York
1993 Venice Biennale; Museum for African Art, New York
1994 Museum of Contemporary Art, Chicago
 Museum for African Art, New York

Gérard Santoni

1943 Born in Divo, Ivory Coast
1964–69 École des Beaux-Arts, Paris and Nice
1969 Diplôme Supérieur des Beaux-Arts, major in painting
1970–73 Chief set designer, Ivory Coast Television
1973– Professor, mural arts, National Institute of Fine Arts,
present Abidjan

Individual Exhibitions
1969 Knoll Gallery, Nice
1970 Maeght Foundation, St. Paule de Vence
1979 Hotel Ivoire, Abidjan
1991 Wright Gallery, New York

Group Exhibitions
1973 First International African Arts Festival, Abidjan
1975 13 International Painting Biennale, São Paulo
1977 FESTAC, Lagos
1980 J. Camp Gallery, New York
1981 Exler Gallery, Frankfurt
1990 French Cultural Center, Abidjan
1992 "Recent Acquisitions," National Museum of African Art, Smithsonian Institution, Washington, D.C.
1993 Venice Biennale; Museum for African Art, New York

Mor Faye

 Born 26 March 1947, died 3 November 1984, Dakar
1961-1964 École des Arts du Sénégal, Section Arts Plastique
 Wins Maison des Arts' *Prix de peinture, Prix de Décoration, Prix de modelage*
1964 Applies for master's degree in art education, École des Arts du Sénégal
1966 Receives degree and is accepted to teach in several colleges
1983 Confined to a mental hospital after denouncing Senegal President Léopold Senghor. Continues to work

Group Exhibitions
1964 Exhibition of layout and mark-up artists, American Cultural Center, Dakar
1966 Premier Festival Mondial des Arts Nègres, Dakar
1970 Dix Ans d'Art au Sénégal, Stockholm
 Semaine sénégalaise, Morocco
 Semaine sénégalaise, Cameroon
1972 Premier Salon des Artistes, Dakar
 Festival d'Ifé, Nigeria
1973 Group exhibition, Rome
 Group exhibition, Tunisia
 Deuxième Salon des Artistes, Musée Dynamique, Dakar
 Arts Plastiques Contemporains du Sénégal, Musée des Beaux Arts, Liège
1974 Arts Plastiques Contemporains du Sénégal, Grand Palais, Paris
1976 Centre Culturel Français de Dakar

Individual Exhibitions
1991 Retrospective, Galerie 39, Dakar
1993 Venice Biennale; Museum for African Art, New York

9436